CROSLEY FIELD

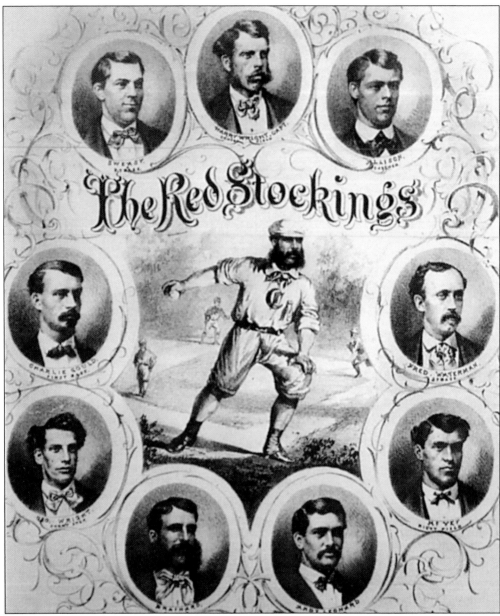

The Cincinnati Red Stockings, baseball's first professional team, played their first game on June 1, 1869, and defeated the Mansfield Independents 48-14. (Author's collection.)

CROSLEY FIELD

Irwin J. Cohen

ARCADIA
PUBLISHING

Published by Arcadia Publishing
Charleston SC, Chicago IL, Portsmouth NH, San Francisco CA

Printed in the United States of America

Library of Congress Catalog Card Number: 2005279808

For all general information contact Arcadia Publishing at:
Telephone 843-853-2070
Fax 843-853-0044
E-mail sales@arcadiapublishing.com
For customer service and orders:
Toll-Free 1-888-313-2665

Visit us on the Internet at www.arcadiapublishing.com

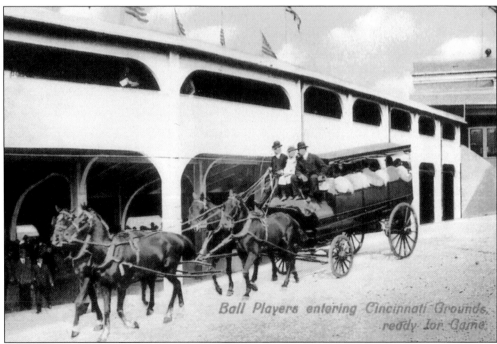

After playing in Union Grounds (1869-70), Avenue Grounds (1876-79), Bank Street Grounds (1880-83), and League Park (1884-1901), Reds owner John Brush built the Palace of the Fans in 1902 on the area where Crosley Field would stand in future years. (Courtesy of Ray Medeiros.)

CONTENTS

Acknowledgments 6

Introduction 7

1. The Early Years 9

2. Redland Field 23

3. The Crosley Years 47

4. The 1950s 77

5. The 1960s 95

ACKNOWLEDGMENTS

When I paid the obligatory visit to the in-laws in Rochester, New York, a favorite stop would be my wife's uncle's home. He would regale me with stories of the baseball players and people who played and worked in the city's legendary Triple-A ballpark—Silver Stadium.

Most of the tales would center around his old baseball buddies, Warren Giles and Gabe Paul. Giles won four successive pennants in Rochester before becoming a front office boss of the Cincinnati Reds from 1937 to 1951.

Giles brought his Rochester sidekicks, Gabe Paul and Red Wings' manager Bill McKechnie, to Cincinnati, and when Giles became National League president, Paul became a top boss of the Reds.

I never met Giles, but when I operated the monthly national *Baseball Bulletin* in the 1970s and Paul ran the Cleveland Indians, I was invited up to his private box in Municipal Stadium to watch a game and chat.

After checking out some of my wife's uncle's stories, the conversation shifted to Paul's years with the Reds. I knew Paul was traveling secretary during those interesting winning Reds years of 1939 and 1940 and was on the scene after the tragic suicide of catcher Willard Hershberger in a Boston hotel room in August 1940.

While I got great stories from the gentlemanly Paul, I didn't get any pictures. However, writer-historian Ken Smith, affiliated with the National Baseball Hall of Fame, provided photos for future use that would be a tribute to the memory of Crosley Field.

The alltime great gentleman, historian, and play-by-play man Ernie Harwell made his collection available through the Burton Historical Collection of the Detroit Public Library, managed by David Poremba. When you see "EHC-BHC-DPL" in a photo credit, you'll know it's from Ernie's collection.

Kudos to another great gentleman, Mr. Ballpark, Ray Medeiros, who contributed many rare images from his wonderful collection, helping to make this a very unique book.

INTRODUCTION

Born in 1869, the Cincinnati Red Stockings were baseball's first professional team and quickly gained fame by winning all of their games that year. Team captain Harry Wright didn't recognize the more than 70 games won and only counted the 57 victories against other National Association clubs as official.

The Red Stockings lost their first game on June 14, 1870, ending a 130-game consecutive winning streak—81 official games and 41 exhibitions. The team played its home games at Union Grounds, which could seat up to 4,000 fans on what would become part of the Union Terminal train station.

The team moved two miles north to Monmouth street and Alabama Avenue and built Avenue Grounds, seating 3,000 in 1876 when Cincinnati became a charter member of the newly formed National League along with other major cities—New York, Chicago, Philadelphia, Boston, St. Louis, Hartford, and Louisville.

1880 saw another move as Bank Street Grounds opened. Located closer to the population center on the north side of Bank Street, south of Western Avenue, the 4,000-seat ballpark boasted a scoreboard featuring out-of-town scores and game lineups. After the season, the National League expelled the Cincinnati franchise for reasons that included the fact that the club sold beer during its games and rented the ballpark on Sundays.

Cincinnati became a member of the new American Association the following season and played in the Association until its readmission to the National League in 1889, joining Brooklyn and the big cities of New York, Philadelphia, Boston, Pittsburgh, Cleveland, and Chicago. During their tenure in the American Association, the team opted for another ballpark featuring a covered grandstand with leather cushioned seats. The site at Findlay and Western Avenue would house parks of different configurations, including Crosley Field.

The Reds played in League Park from 1884 to 1901 and rebuilt the main grandstand following a fire in 1902. The fancy little ballpark, which looked more like an outdoor opera house, contained numerous hand-carved pillars and columns and 19 fashion boxes. It became known as Palace of the Fans. Fire destroyed the ornate ballpark after the 1911 season and Redland Field was built on the site, opening in 1912.

Seven years later, Cincinnati hosted its first World Series. Redland Field was renamed Crosley Field in 1934 and the club made history that year by becoming the first major league team to use an airplane to travel (from Cincinnati to Chicago.).

The first night game in major league history was played in Crosley Field on May 24, 1935,

and it was three days later that Babe Ruth played under the shadows of the light towers on his last road trip as an active player.

Crosley Field was the site of the 1938 All-Star Game and the 1939 and 1940 World Series. The Reds lost more games than they won in the 1940s and 1950s. However, the Reds did have winning records in 1956 and 1957, and it was in those years that I got to see the Reds while growing up in Detroit. The Reds and Tigers played an annual exhibition game to benefit sandlot baseball in the Tigers' home park, then called Briggs Stadium. The upper bleachers were the place to be to see the big bats from Cincinnati—Ted Kluszewski, Gus Bell, Wally Post, Jim Greengrass, and Smokey Burgess—take batting practice and deposit baseballs.

I was able to follow the Reds via a powerful Cincinnati radio station and their special play-by-play man and master storyteller, former major league pitcher Waite Hoyt. As the Reds stars of the late 1950s faded or were traded, the team won only 67 games in 1960, but the rebuilt Reds won 93 games in 1961 and Crosley Field saw its last World Series.

I saw my first game in Crosley Field in 1963, the same year Cincinnati native Pete Rose was a rookie second baseman for the Reds. I was pleasantly surprised that the odd little ballpark was bright and freshly painted, and the red seats were very fitting for a team named the Reds.

The Reds played their last game in Crosley Field on June 24, 1970, before an almost capacity 28,027 paying fans, and finished their pennant-winning season in Riverfront Stadium as the old ballpark faded into history.

ONE

The Early Years

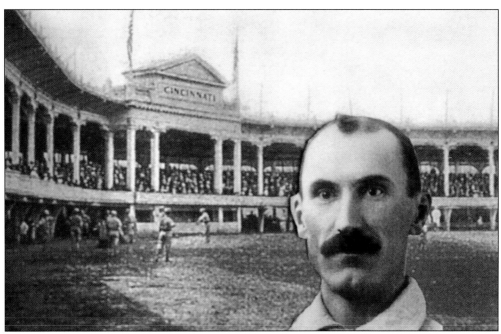

Hall of Famer Jake Beckley, who played more games at first base than any other major leaguer and batted over .300 13 times, played for Cincinnati from 1897 to 1903. (Author's collection.)

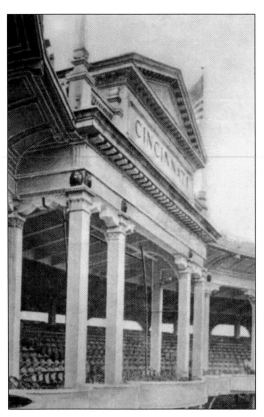

The Palace of the Fans featured hand-carved pillars and columns and 19 opera-type semicircular boxes.

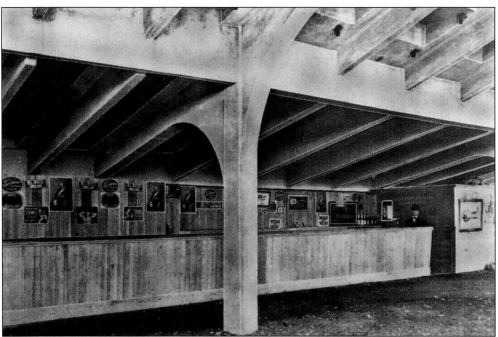

Two bars underneath the stands sold beer and whiskey. The seating area below the main grandstand was called "Rooters Row." (Courtesy Ray Medeiros.)

Speedy deaf outfielder William Ellsworth Hoy was known as "Dummy," but he was also known as a smart ballplayer, and he taught his teammates how to sign. Hoy played for Cincinnati in the 1890s and again in 1902. An active 99-year-old in 1961, the Reds honored baseball's then-oldest living former ballplayer by giving Hoy the honor of throwing out the first ball prior to game four of the World Series at Crosley Field. (Author's collection.)

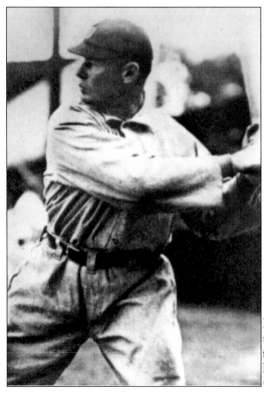

Best known as a Hall of Fame outfielder with the Tigers, Sam Crawford played for the Reds from 1900 to 1902 and led the National League in home runs with 16 in 1901. (EHC-BHC-DPL.)

A catcher for the Reds since 1896, Heinie Peitz batted .305 in 1901 and .315 in 1902 and stayed with Cincinnati through 1904 before moving on to the Pirates.

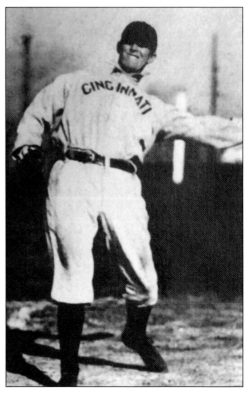

With Cincinnati from 1899 to 1905, Frank "Noodles" Hahn won 22 games in 1901, 1902, and 1903. (EHC-BHC-DPL.)

A fine pitcher whose hitting made him a regular outfielder with Cincinnati, James "Cy" Seymour led the league in 1905 with 219 hits, 40 doubles, 21 triples, and 121 runs batted in. His .377 average was the highest individual Reds season mark. After playing in the International League until 1916, Seymour tried a big league comeback at the age of 46. He died about a year later from tubercular phthisis.

A pitcher for 11 years, Bob Ewing had his best year in 1905, winning 20 and losing 11 while posting a 2.51 ERA. In later years, Ewing served two terms as sheriff of Auglaize County, Ohio. (EHC-BHC-DPL.)

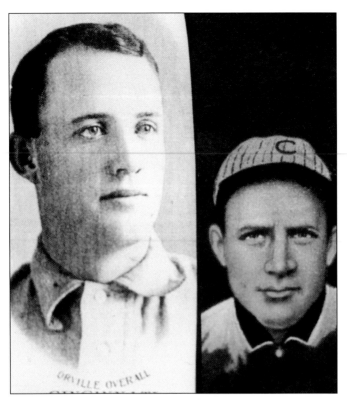

Orval Overall lost 22 games for the Reds in 1905 but would win 23 games for the Cubs two years later. After his baseball life, Overall became a vice president and manager of a California bank.

A Hall of Fame outfielder, Joe Kelley was player manager in 1902. After two fourth place finishes, Kelley's club finished third in 1904 before dropping to fifth in 1905. Kelley's managerial title was dropped in 1906 and he returned to the playing field for 129 games but batted only .228. (Author's collection.)

Harry Steinfeldt spent eight years with the Reds and led the National League in doubles with 32 in 1903 while hitting .312. Traded to the Cubs in 1906, he became the regular third baseman in the famous Tinker-to-Evers-to-Chance infield.

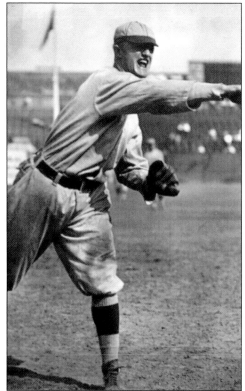

Mike Mowrey was used mostly as a third baseman by the Reds from 1905 to 1909. Staying in the big leagues for another eight years with three other clubs, he went on to manage in the minor leagues and worked as a night watchman. (EHC-BHC-DPL.)

Speedy outfielder Mike Mitchell had his best year of his six-year Cincinnati career in 1909. Mitchell batted .310 with a league-leading 17 triples, and he stole 37 bases.

Catcher William "Ducky" Pearce only had four big league at-bats in his career. Pearce batted twice in 1908 and 1909 without getting a hit and moved on to play in several minor leagues before operating a lunch counter and filling station. (EHC-BHC-DPL.)

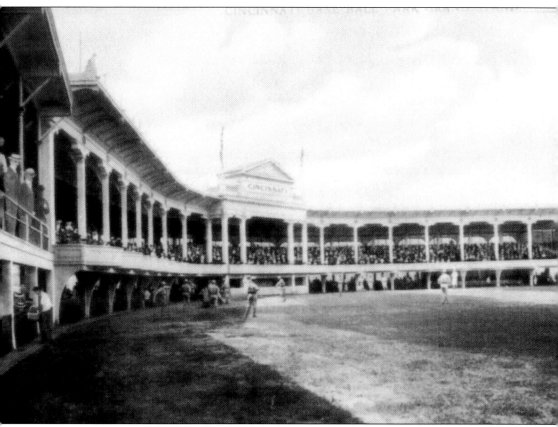

In 1909 the Reds passed the 400,000 attendance mark for the first time and drew 424,643 to the Palace of the Fans as the club's 77-76 record placed them fourth in the National League. (Courtesy Ray Medeiros.)

Bob Spade pitched for the Reds from 1907 until 1910 before opening a bar. Prohibition closed his establishment and Spade became a dealer in bootleg whiskey. Atrophic cirrhosis of the liver ended his life at 47.

Infielder-outfielder Hans Lobert played for the Reds from 1906 through 1910 during a 14-year career. From 1918 to 1925, Lobert was the baseball coach at the United States Naval Academy and went on to manage the Phillies and scout for the Giants. (Author's collection.)

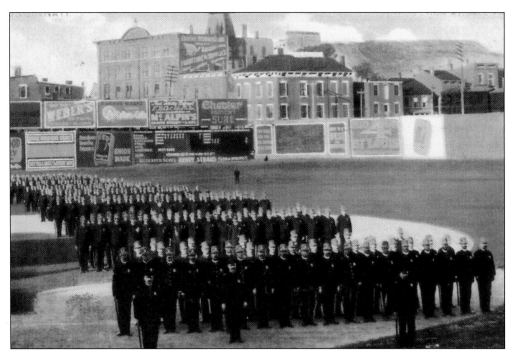

Many times during the early years, fans were treated to pre-game ceremonies such as a police inspection by Cincinnati law enforcement officials. (Courtesy Ray Medeiros.)

Ace pitcher George Suggs, who once picked off seven base runners in a single game, won 19 games for the Reds in 1919 and two years later although the club had losing seasons. (EHC-BHC-DPL.)

After winning 240 games as a pitcher, Clark Griffith became the Reds manager in 1909 and the club finished fourth. Griffith's Reds finished fifth the following year and sixth in 1911. (EHC-BHC-DPL.)

Infielder Tom Downey played all infield positions and appeared in more than 100 games in three consecutive seasons before being traded in the 1912 season.

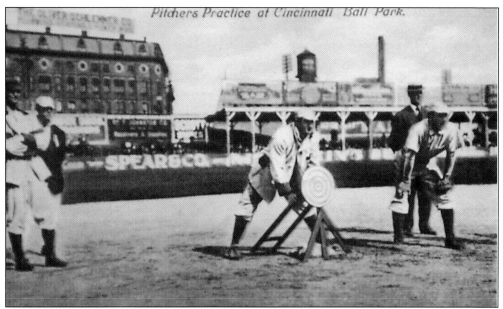

Pirates star Honus Wagner stands behind a bullseye during pre-game warmups at the Palace of the Fans. (Courtesy Ray Medeiros.)

First baseman Dick Hoblitzell led the National League with 622 at-bats in 1911. His .289 batting average included 19 doubles and 11 home runs. Hoblitzell also managed to steal 32 bases. (Author's collection.)

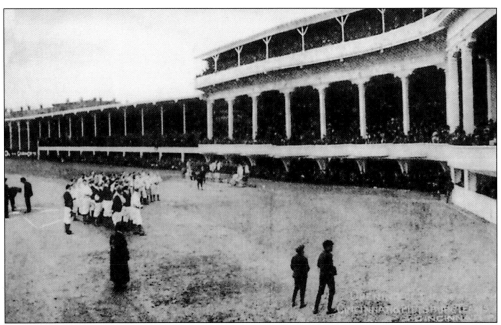

1911 was the last season for the Palace of the Fans as the famed little ballpark was demolished to make way for a new concrete and steel structure on the site. (Courtesy Ray Medeiros.)

Two

Redland Field

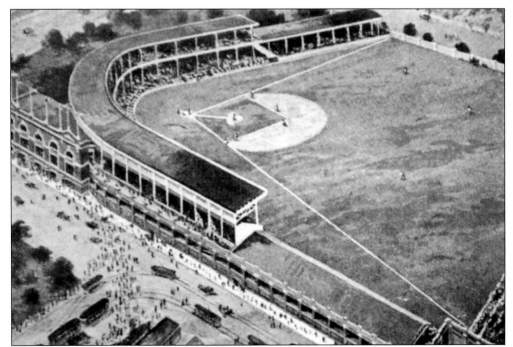

Redland Field was constructed over the winter and opened April 11, 1912, with a 10-6 victory over Chicago. At its opening, the ballpark featured a large playing field with 360-foot foul lines and 420 feet to the center field wall. However, architectural plans showed a distance of 400 feet down the right field line. (Courtesy Ray Medeiros.)

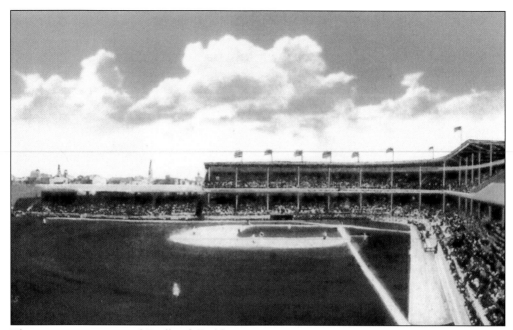

The seating capacity of Redland Field was given at 20,696. However, on Opening Day thousands poured into the standing room area in right field as good weather brought out 26,336 paying fans. (Courtesy Ray Medeiros.)

One of the tallest players of his time at 6-foot-5, catcher Larry McLean played for the Reds from 1906 to 1912. He then played for John McGraw's New York Giants but was cut in 1915 after trying to punch McGraw outside a St. Louis hotel. He was shot to death by a Boston bartender in 1921. (EHC-BHC-DPL.)

Infielder Eddie Grant attended Harvard, and after two seasons with the Reds in which he played in the Palace of the Fans and Redland Field, he was traded to the New York Giants in 1913. Grant was the first major leaguer to volunteer in World War I and was killed in action in 1918. The Edward L. Grant Highway in the Bronx was named as a tribute to his memory. (Courtesy Hy Mandell.)

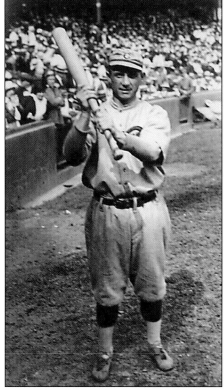

Henry "Heinie" Groh came to the Reds from the Giants in the Eddie Grant deal in 1913. Groh stayed in the majors until 1927 and became a minor league manager and scout and worked as a cashier at a Cincinnati area racetrack. (Courtesy Hy Mandell.)

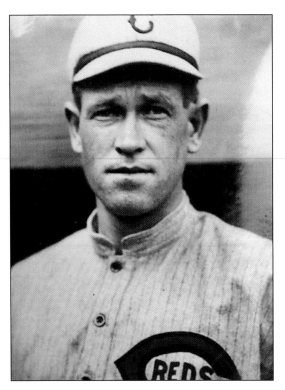

First baseman Hal Chase batted .291 over 15 years but was probably a much better ballplayer than his average indicates, as he was accused of accepting bribes to throw games several times. Chase led the league while playing for the Reds in 1916 by batting .339. Traded to the New York Giants in 1919, Chase was banned from the game after the season for his role in helping to engineer the Black Sox scandal through his gambling contacts.

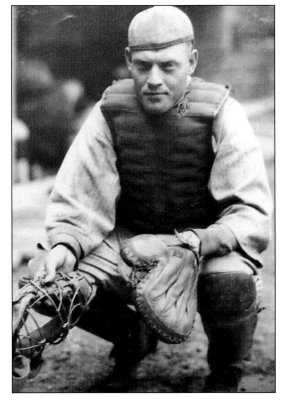

Catcher Ivey "Ivy" Brown Wingo broke in with the Cardinals in 1911 and came to the Reds in 1915. The following season, with the club mired in last place, Wingo was tapped to manage the Reds for two games until new manager Christy Mathewson arrived. Wingo would stay on the Reds roster until 1929 and at the time of his retirement held the National League record of most games caught with 1,231. (EHC-BHC-DPL.)

Earl "Greasy" Neale stole second base, third, and home in the same inning on August 15, 1919. Neale swiped 28 bases that year while batting .242. In 28 at-bats in the 1919 World Series, he hit .357.

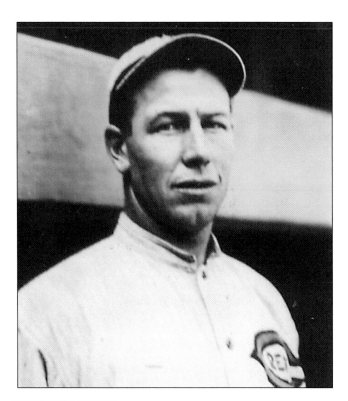

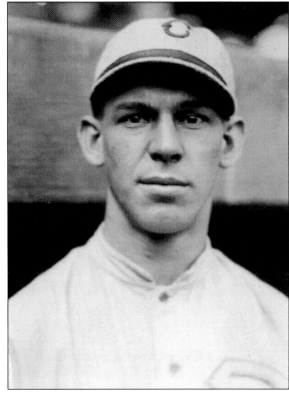

Ed Gerner's big league career consisted of surrendering 22 hits in 17 innings spanning five games, good enough for a 1-0 record in the Reds' 96-44 pennant-winning 1919 season. (EHC-BHC-DPL.)

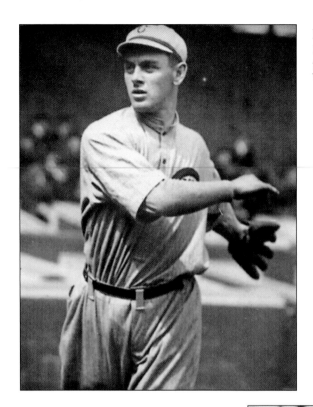

Hod Eller threw a no-hitter on May 11, 1919 and won 20 games during the season and two more in the World Series.

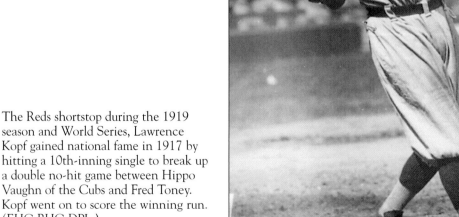

The Reds shortstop during the 1919 season and World Series, Lawrence Kopf gained national fame in 1917 by hitting a 10th-inning single to break up a double no-hit game between Hippo Vaughn of the Cubs and Fred Toney. Kopf went on to score the winning run. (EHC-BHC-DPL.)

First baseman Jake Daubert led the league in batting in 1913 and 1914 and the Reds acquired him from Brooklyn for the 1919 season.

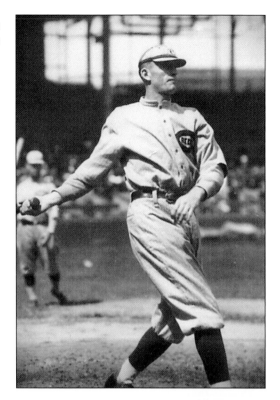

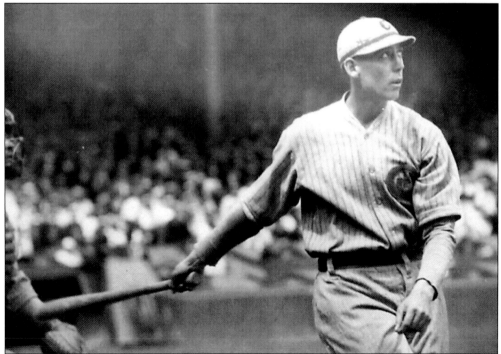

Center fielder Edd Roush came to the Reds from the New York Giants in 1916 and led the league in hitting in 1917 and 1919. (EHC-BHC-DPL.)

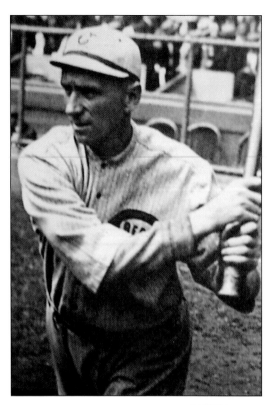

In the big leagues since 1904, Sherry Magee joined the Reds in mid-1917 and proved valuable by hitting .321 in 45 games. In 1918, while playing first, second, and third base and outfield, Magee hit .298 in 400 at-bats. At the age of 35 in 1919, Magee dropped to .215 and his 16-year career ended after the World Series, in which he had one hit in two trips to the plate.

Sidearmer Harry "Slim" Sallee had a nifty 21-7 record and a low 2.06 ERA for the Reds in 1919. After he left the majors with a 173-143 record and a fine 2.56 ERA over 14 years, Sallee operated a tavern in his native Higginsport, Ohio. (Courtesy Hy Mandell.)

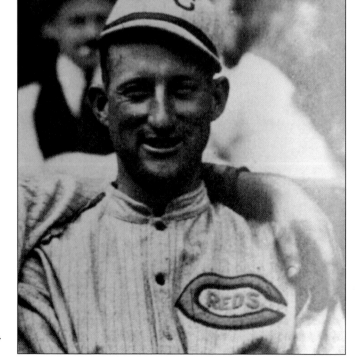

Dutch Reuther pitched 243 innings in 1919 and compiled a sparkling 1.81 ERA while throwing 20 complete games and winning 19 of 25 games for a league-leading .760 percentage. Reuther would pitch for the Reds for another ten seasons.

Under manager Pat Moran, the Reds posted a 96–44 record in the 1919 140-game war-shortened season. The Reds won 52 games at home while losing only 19. (Courtesy Hy Mandell.)

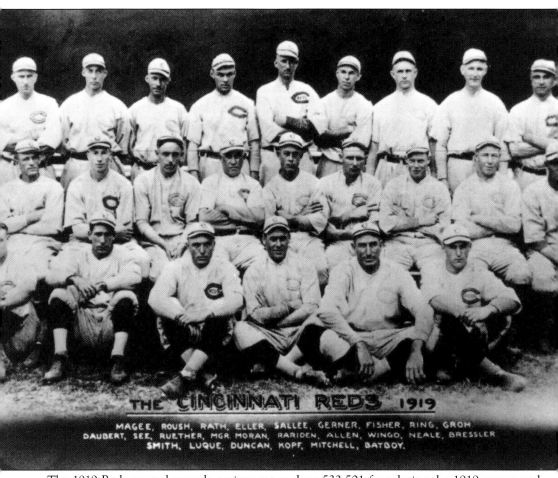

THE CINCINNATI REDS 1919

MAGEE, ROUSH, RATH, ELLER, SALLEE, GERNER, FISHER, RING, GROH
DAUBERT, SEE, RUETHER, MGR. MORAN, RARIDEN, ALLEN, WINGO, NEALE, BRESSLER
SMITH, LUQUE, DUNCAN, KOPF, MITCHELL, BATBOY.

The 1919 Reds created enough excitement to draw 532,501 fans during the 1919 season and 106,147 for four World Series games in Cincinnati. The Reds took the World Series five games to three—many were suspicious of the poor play by some members of the White Sox team. (Courtesy B&W Photos.)

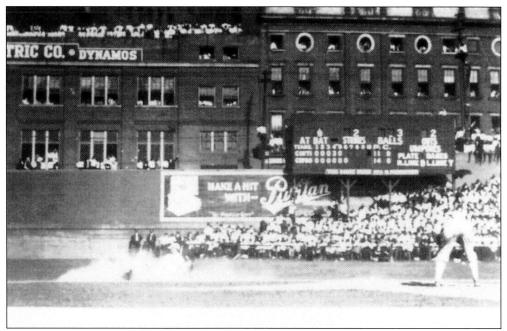

The World Series drew fans to every vantage point. Notice fans in the windows of buildings behind the outfield wall and the spectators on the roof of the electric company (top left).

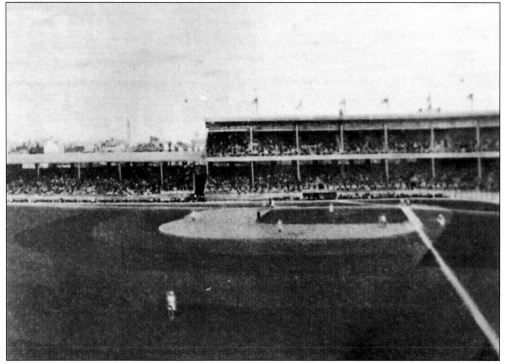

The 1920 Reds topped their previous attendance record and drew 568,107 as the club dropped to second place, winning 82 games, 14 fewer than the year before. (Courtesy Ray Medeiros.)

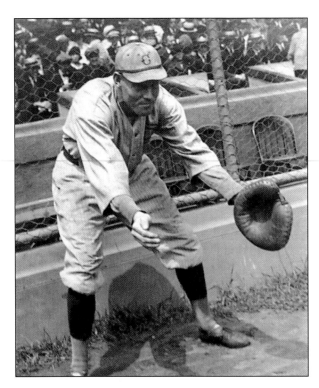

Catcher Bill Rariden batted .216 as a backup in 1919 and .211 in the World Series. After hitting .248 in 1920, Rariden returned to his hometown of Bedford, Indiana, and operated a filling station.

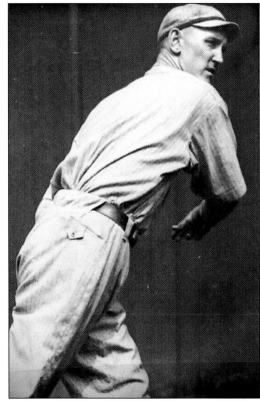

Jimmy Ring broke in with the Reds in 1917 and won 10 games in 1919 and 17 in 1920 before being traded to the Phillies that winter with Greasy Neale for pitcher Eppa Rixey. (EHC-BHC-DPL.)

The distance down the left field line was shortened from 360 to 320 feet in 1921, and outfielder Pat Duncan's home run over the left field wall in June of that year was the first ball ever to clear an outfield wall at Redland Field. Duncan, who would spend six of his seven years in the majors with the Reds, hit over .300 three times.

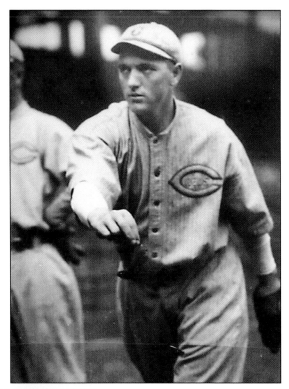

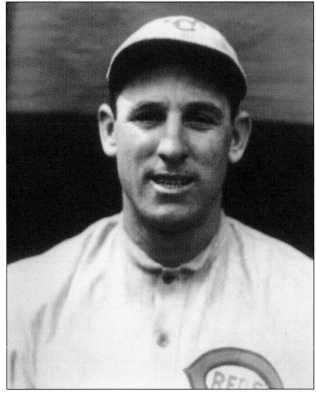

Infielder Sammy Bohne, who was born in San Francisco as Sammy Cohen, spent six of his seven big league years with the Reds. Bohne saw the most action in 1921, when he played in 102 games at second base and 53 games at third while batting .285 in 613 trips to the plate. (George Brace photos courtesy EHC-BHC-DPL.)

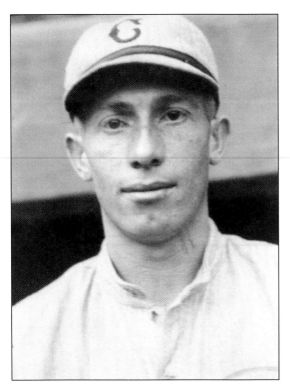

Charlie See was a backup outfielder for the Reds in 1919, 1920, and 1921 and saw action in 92 games over his three-year career. See had one home run in 202 at-bats while compiling a .272 career average. See became an automobile salesman after his baseball days and died aboard his boat in Bridgeport, Connecticut, in 1948.

Lew Fonseca began his 12-year big league career with the Reds in 1921. Fonseca, who played all positions, would lead the league in hitting with a .369 average while playing for Cleveland in 1929. Fonseca would become a pioneer in using film for instructional and promotional use for major league baseball. (EHC-BHC-DPL.)

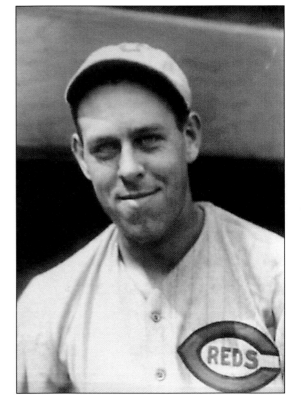

Eppa Rixey, who lost 21 games in 1917 and 22 in 1920 with the Phillies, came to the Reds in 1921 and won 25 games in 1922.

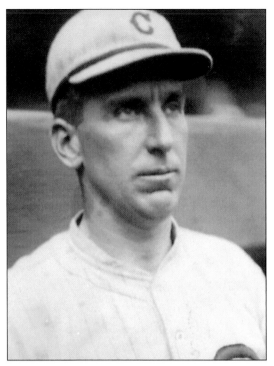

Infielder Ralph "Babe" Pinelli, a native of San Francisco who played with area kids Sammy Bohne and Lew Fonseca, was reunited with his childhood chums on the Reds in 1922. Pinelli played in 156 games at third base in 1922 and batted .305. He would stay with the Reds until 1927. He became an umpire for three decades and umped Don Larsen's perfect game in the 1956 World Series. (EHC-BHC-DPL.)

One of the first Cuban ballplayers, Dolf Luque pitched 28 complete games in 1923 while leading the league in wins (27) and ERA (1.93). Luque would win 154 games in his career.

Outfielder Curtis Walker never seemed to get the national recognition his stats deserved. Walker came to the Reds in 1924 and hit .300 or better five times for them. Walker had a .304 lifetime average over 12 seasons. He served in both world wars and operated a funeral home in Texas. (Courtesy Hy Mandell.)

Manager Pat Moran died during spring training in 1924, but the season opener drew the largest crowd ever as 35,747 squeezed their way into Redland Field. The fans were disappointed as the team headed to fourth place that year but suffered another devastating blow late in the season. Jake Daubert, the great defensive first baseman who hit .300 or more ten times in his career, died from acute appendicitis. (Courtesy Ken Smith.)

Carl Mays, a 20-plus game winner four times in nine previous seasons, joined the Reds in 1924 and posted a 20-9 record. As a member of the Yankees in 1920, Mays threw the pitch that killed Cleveland shortstop Ray Chapman.

Pete Donohue won 21 games in 1923 and again two years later. The righthander won 20 games in 1926. (Courtesy Ken Smith.)

Hall of Fame catcher Eugene "Bubbles" Hargrave carried a lifetime .310 average in his 12-year career. Hargrave led the league with a .353 average in 1926.

Rube Bressler began his big league career as a pitcher winning 26 and losing 32 with a 3.40 ERA before becoming a first baseman and rattling off batting averages of .347, .348, and .357 in 1924, 1925, and 1926 for the Reds. Bressler hit .301 over 19 years and went on to operate a Cincinnati restaurant. (Courtesy Ken Smith.)

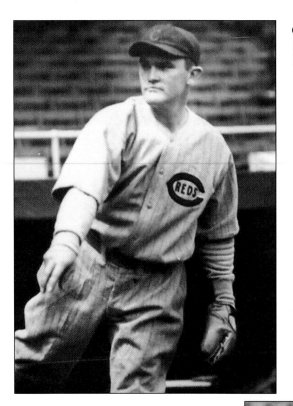

Charles "Red" Lucas won 18 games in 1927 and 19 two years later. Lucas won 157 games in a 15-year big league career.

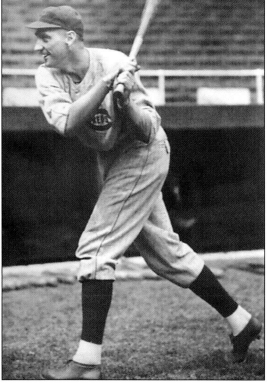

George "Highpockets" Kelly, a 6-foot-4-inch first baseman, broke in with the New York Giants in 1915, came to the Reds in 1927, and hit .270. He followed with .296 and .293 averages before being traded in 1930. Kelly had a career .297 average over 16 years. (Conlin Photos, Ken Smith.)

Infielder Charlie Dressen broke in with the Reds in 1925 and hit .292 in 1927 and .291 in 1928. After his playing days, Dressen would coach and manage in three different decades.

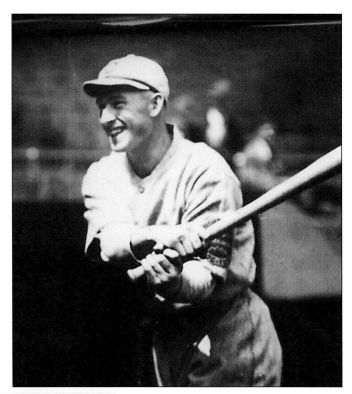

Horace "Hod" Ford played for the Phillies and Dodgers before coming to the Reds in 1926. In 1927, playing mainly at shortstop, Ford hit his only home run that year as the addition of field boxes created changes in foul line distances. The left field line was shortened to 339 feet; center became 395 feet, and right field, 377 feet. (Conlin photos, Ken Smith.)

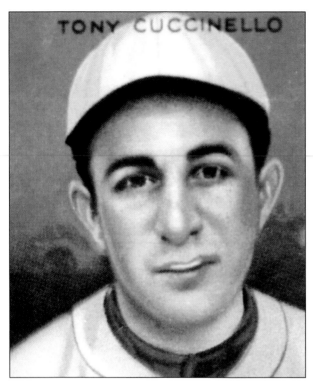

Infielder Tony Cuccinello hit over .300 in his first two seasons with the Reds. During spring training in 1932, he was part of a six-player trade with the Dodgers that would bring Babe Herman and Ernie Lombardi to the Reds.

Leo Durocher was a weak-hitting shortstop for the Reds in 1932, batting only .217 in 143 games. (Courtesy Ken Smith.)

Babe Herman (left) and Chick Hafey were newcomers with the Reds in 1932. Herman came from the Dodgers in the Cuccinello deal, and Hafey arrived in a trade from the St. Louis Cardinals. Herman hit .326 in 577 at-bats while Hafey hit .344 in 253 trips to the plate. (Courtesy B&W Photos.)

After 21 years in the majors, Eppa Rixey retired in 1933 with a 266-251 record. He had four 20-win seasons, including three with the Reds. Rixey operated a successful insurance business in Cincinnati.

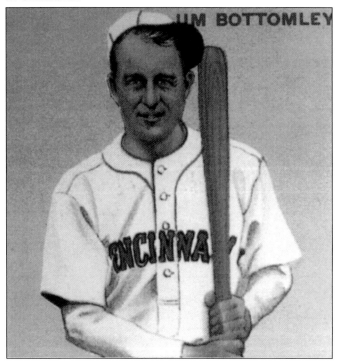

"Sunny" Jim Bottomley was the National League's Most Valuable Player in 1928 and played in four World Series with the Cardinals. He would spend 1933 through 1935 with the Reds and finished his 16-year career with St. Louis while posting a .310 lifetime average. (Courtesy Ken Smith.)

THREE

The Crosley Years

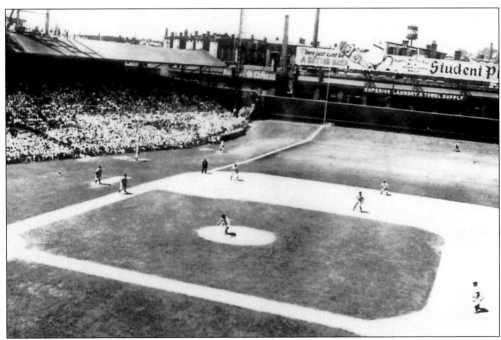

In February 1934, radio station owner and entrepreneur Powell Crosley, Jr., bought the Reds and renamed the ballpark Crosley Field. After finishing second in 1928, the Reds followed with two fifth-place finishes and two seventh, and would come in last from 1931 through 1934. (Courtesy Ray Medeiros.)

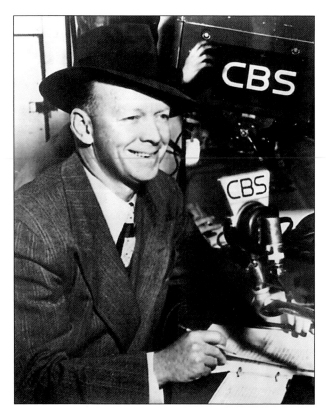

Crosley hired Red Barber as radio voice of the Reds. When Barber relayed the play-by-play on April 17, 1934, it was his first big league broadcast and the first regular season game between two major league teams he ever saw. (Courtesy B&W Photos.)

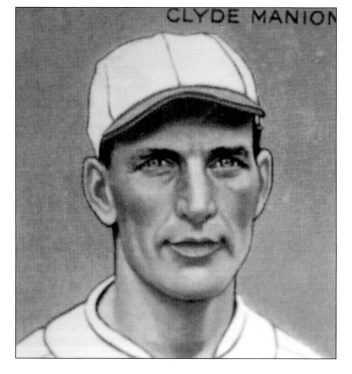

Clyde Manion spent the last three seasons of his 13 years in the majors with the Reds. The reserve catcher batted .207 in 1932, .167 in 1933, and .185 in 1934 for a .217 career average. The Reds numbers were also poor. The club posted its lowest winning percentage in 1934—.344—as the Reds won 52 and lost 99. (Author's collection.)

Infielder Tony Piet had his best season of his eight year career with Pittsburgh in 1933, hitting .323. In 1934, Piet, who would go on to become a well-known Chicago auto dealer, hit .259 in 106 games for the Reds.

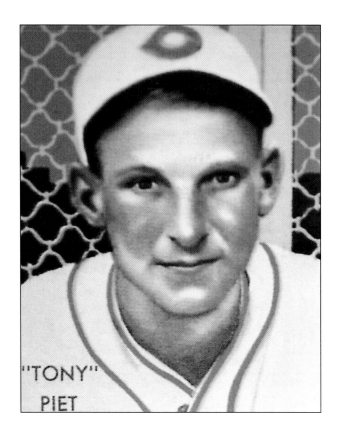

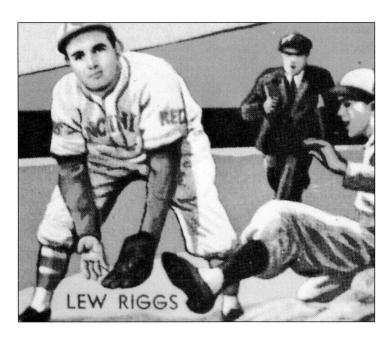

Lew Riggs played for the Reds from 1935 to 1940. As the regular third baseman in 1935, Riggs hit .278. (Author's collection.)

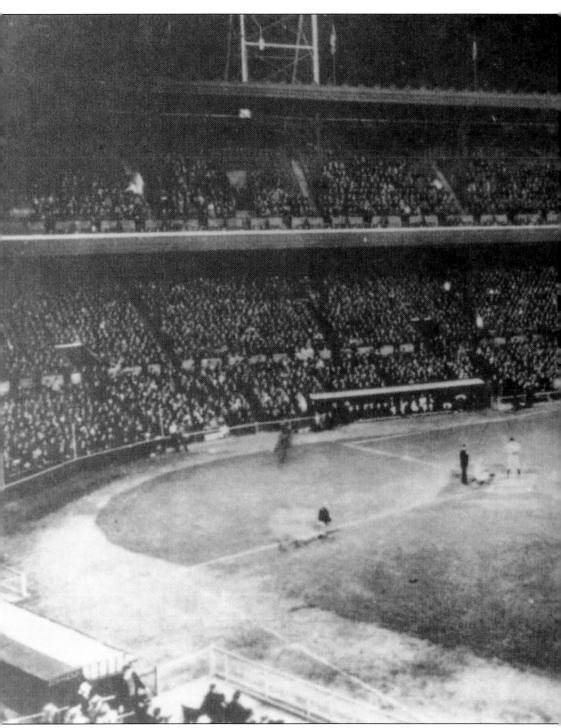

The Reds drew only 207,000 in 1934, down some 11,000 from 1933. General manager Larry MacPhail had Crosley Field readied for night baseball and the first big league game under the lights was scheduled for May 23, 1935. Rain postponed the historic game until the following night, keeping the crowd down to 20,422. Reds fans went home happy as Paul Derringer beat

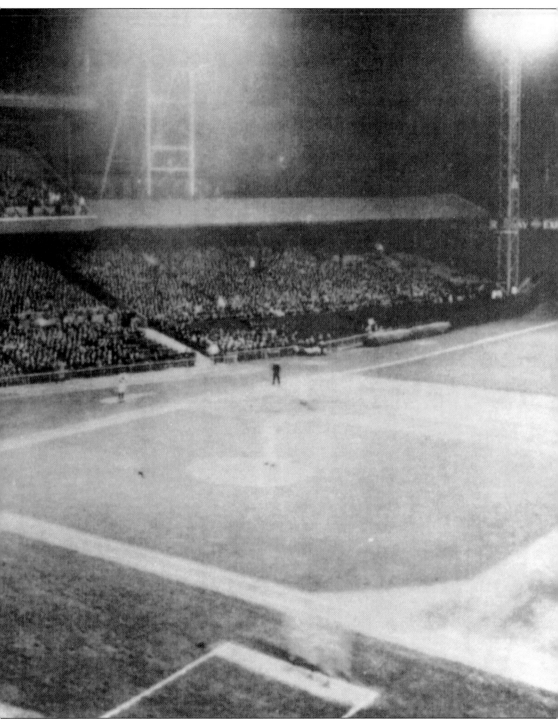

the Phillies 2-1. Former Reds third baseman Ralph "Babe" Pinelli was the home plate umpire that night. The seven night games at Crosley Field in 1935 drew 130,337, an average of 18,620. The remaining 69 day games drew 317,910, averaging 4,607. Total attendance for the sixth-place Reds that year was 448,247. (Courtesy Ray Medeiros.)

Benny Frey broke in with the Reds in 1929 and was traded to St. Louis in 1932 and then back to the Reds the same year. His career in the majors and with the Reds ended in 1936 with a 57-82 record and a 4.50 ERA. Sadly, Frey took his own life the following year.

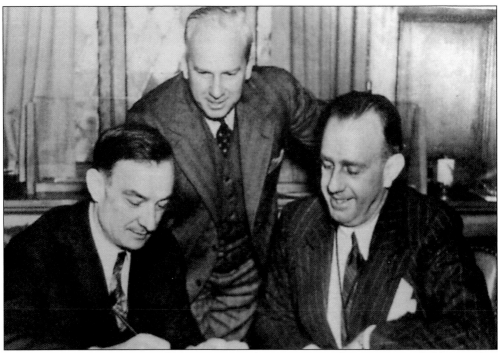

After the team dropped from fifth in 1936 to last in 1937, Bill McKechnie (left) signed to manage the Reds. General manager Warren Giles stands between his new manager and team owner Powell Crosley, Jr. (Courtesy Ken Smith.)

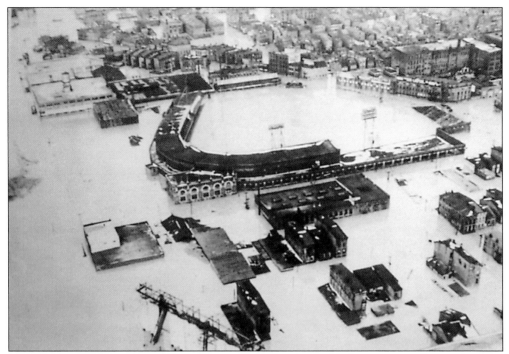

Prior to the 1937 season, flood waters swept over Crosley Field. At one point, home plate was under 21 feet of water.

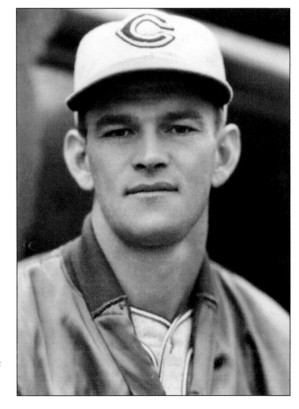

In 1937 Lee Grissom had a 12-17 record over 223.2 innings. It was the only season in his eight year big league career that he pitched in over 154 innings. (Courtesy Ken Smith.)

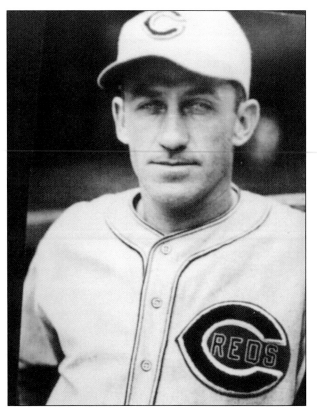

Hazen "Kiki" Cuyler had his first taste of the big leagues with Pittsburgh in 1921. With the Cubs from 1928 until into the 1935 season, Cuyler stayed with the Reds through 1937 before finishing his Hall of Fame career with the Dodgers. Cuyler, who batted .321 over 18 years, was a coach for the Red Sox at the time of his death in 1950.

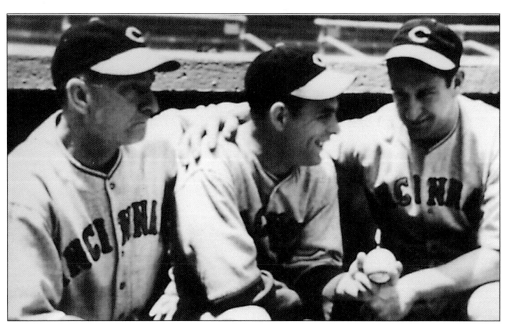

Manager Bill McKechnie (left) listens as Johnny Vander Meer (center) tells catcher Ernie Lombardi about pitching back-to-back no-hitters in June 1938.

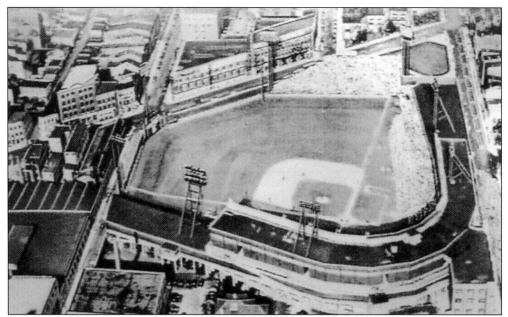

In 1938 home plate in Crosley Field was moved 20 feet toward the outfield walls. Left field was shortened 11 feet to 328. Center field was shaved 20 feet to 375, and right field measured 366 feet, 11 feet shorter than before. The deepest part of the ballpark was only 383 feet away. The AltStar Game, held on July, 6, 1938, drew 27,067. (Courtesy Ray Medeiros.)

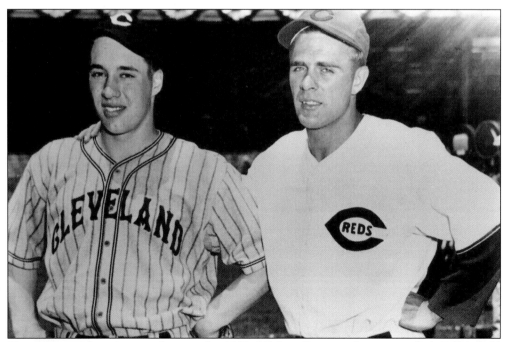

Two young pitchers are seen here at the 1938 All-Star Game in Cincinnati. Bob Feller (left) was only 19 years old. Johnny Vander Meer, the starting pitcher, pitched three innings and only gave up one single. Vander Meer rattled off ten consecutive victories in 1938 on his way to a 15–10 record with a 3.12 ERA. (Courtesy B&W Photos.)

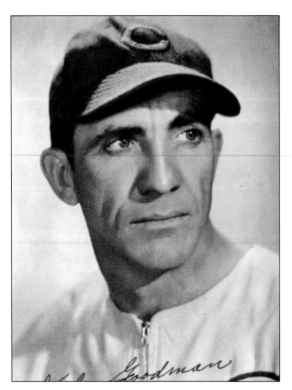

Ival Goodman became a regular Reds outfielder in 1935 and stayed in the role through 1940. A part-timer in 1941 and 1942, he finished his 10-year career with the Cubs. Goodman's best season was 1938, when he powered 30 home runs and hit .292.

One of the most popular Reds players of all time, catcher Ernie Lombardi carried a powerful bat in 1938. He led the league with a .342 batting average and was named the National League's Most Valuable Player. Lombardi's prominent nose earned him the nickname "Schnozz." (Courtesy B&W Photos.)

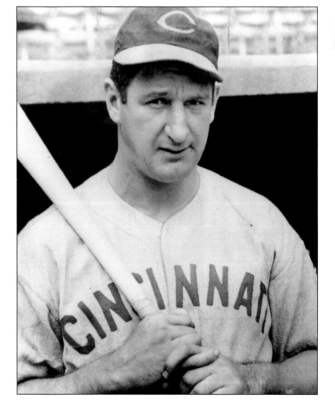

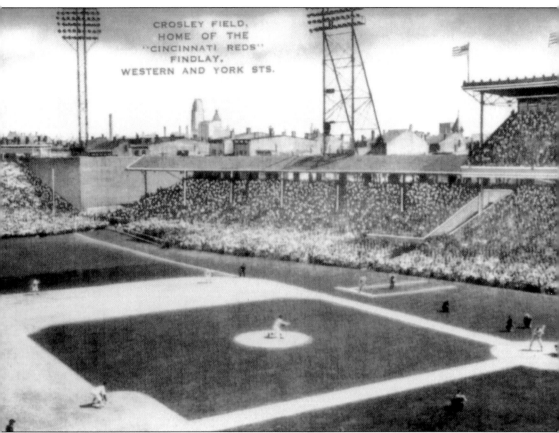

The 1938 Reds finished fourth with a winning record of 82-68, a .547 winning percentage. The last time the Reds had a winning season (.513) was in 1928. 1938 also marked the first time attendance passed 700,000 as the Reds drew 706,756 into Crosley Field. (Courtesy Ray Medeiros.)

After pitching for the Yankees, Red Sox, and Athletics in the first 11 years of his 12-year career, Hank Johnson appeared in 20 games for the Reds in 1939, going 0–3, which gave him career marks of 63–56, 4.75 ERA

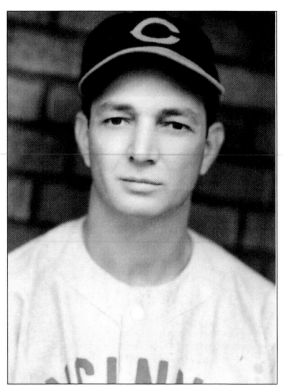

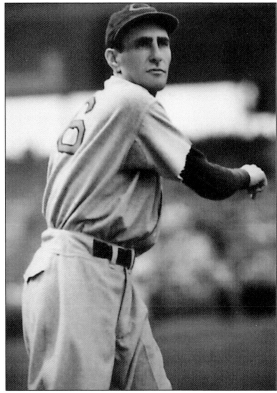

Johnny Niggeling saw action in 10 games with the 1939 Reds. He had a 2-1 record with a 5.80 ERA and didn't get into the World Series. Niggeling's nine-year career ended the following year with the St. Louis Browns. He committed suicide by hanging in 1963. (EHC-BHC-DPL.)

Lee Gamble only saw action in two games in 1935 and would be a backup outfielder with the Reds in 1938, 1939, and 1940. Gamble was hitless in one at-bat in the 1939 World Series.

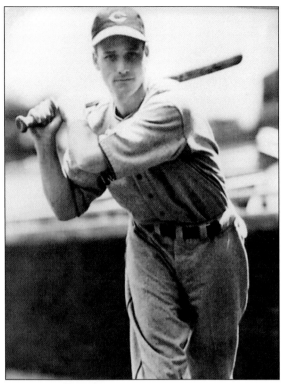

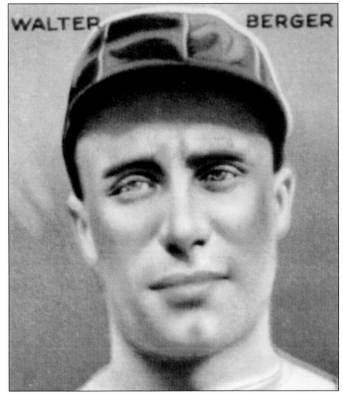

After seven full seasons with the Braves, outfielder Wally Berger was traded to the Reds in June 1937. Berger moved to the Giants and back to the Reds the following season. He was part of the 1939 pennant-winners and posted a career .300 average over 11 seasons. (EHC-BHC-DPL.)

Infielder Linus Frey was the second baseman in the 1938 All-Star Game and hit .291 in 1939, but was hitless in 17 trips to the plate in the 1939 World Series. Frey would stay with the Reds through 1946 and move on to the Cubs, Yankees, and Giants.

1939 was Stanley "Frenchy" Bordagaray's only season with the Reds, and the reserve outfielder and infielder only batted .197, the worst average of his 11-year career with five other National League clubs. (Courtesy Ken Smith.)

Bucky Walters broke in as an infielder with the Braves in 1931. After a couple of years of mixing pitching and infielding, he stayed on the mound in 1938. In 1939 he won 27 games for the Reds, leading the league in wins and ERA (2.29).

Paul Derringer, who won 22 games for the Reds in 1935 and 21 in 1938, won 25 while losing only seven in 1939. (Courtesy Ken Smith.)

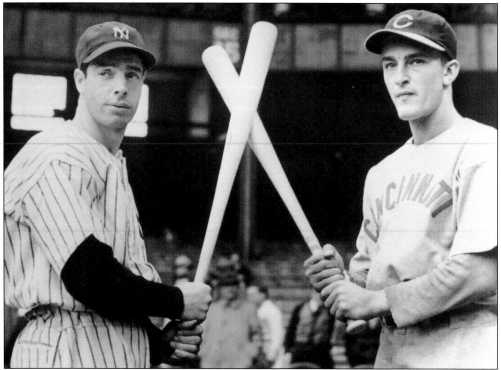

The World Series showcased two of the game's best young hitters, Joe DiMaggio (left) and Frank McCormick. DiMaggio hit .381 with 30 home runs in the regular season and .313 with one home run in 16 at-bats in the Series. McCormick's regular season numbers were .332 with 18 homers. He batted .400 in 15 at-bats in the World Series. (Courtesy B&W Photos.)

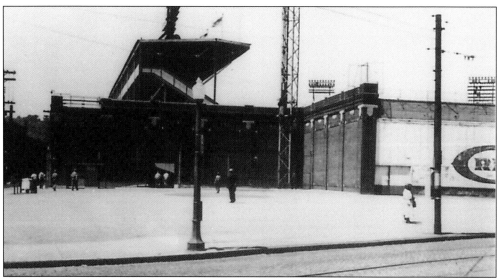

The pennant-winning Reds of 1939 drew a Crosley Field high of 981,443. A second deck along the foul lines was in use in the latter part of the season, bringing the seating capacity to 29,401. The Yankees won the World Series four games to none, but games three and four in Cincinnati drew crowds of 32,723 and 32,794. (Courtesy Ray Medeiros.)

Outfielder Mike Dejan got into 12 games and played in two games for the 1940 Reds, batting 16 times with three hits for a .188 average before slipping out of the big leagues forever.

On August 3, 1940, catcher Willard Hershberger, 29, committed suicide in a Boston hotel room. He was the first big leaguer to take his own life during the regular season. In 402 trips to the plate over three seasons, Hershberger batted .316. (EHC-BHC-DPL.)

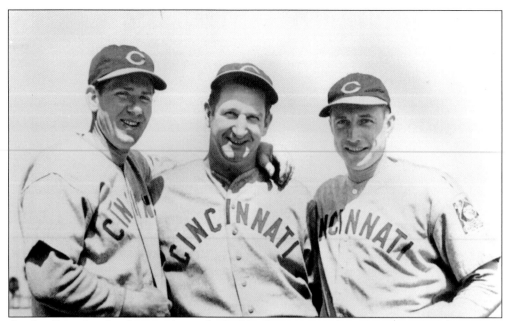

Catcher Ernie Lombardi enjoys being flanked by dominant pitching teammates. Paul Derringer (left), who won 29 games in 1939, won 20 in 1940 while throwing 26 complete games. Bucky Walters, who won 27 in 1939, led the league in wins with 22 in 1940 and in ERA with 2.48. (Courtesy B&W Photos.)

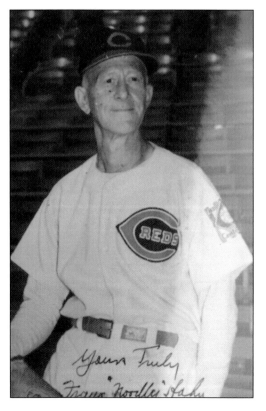

Noodles Hahn spent seven seasons with the Reds from 1899 to 1905 and was a 20-game winner four times. In 1940, at the age of 61, Hahn threw batting practice in the World Series. (EHC-BHC-DPL.)

Outfielder Harry Craft, in the fourth year of a six-year career with the Reds, batted .244 in 1940 and was hitless in one World Series at-bat. Craft coached and managed in the big leagues from 1955 to 1964. (EHC-BHC-DPL.)

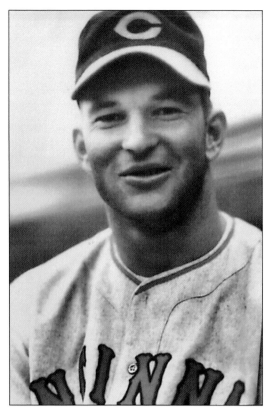

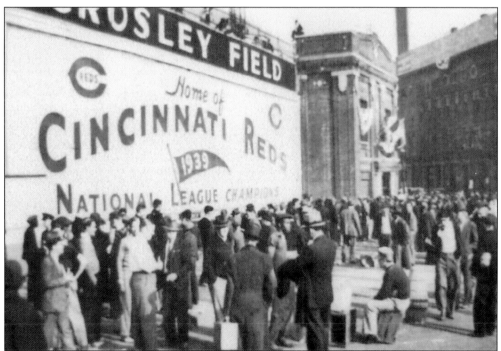

Attendance in 1940 dropped 131,263 from 1939 to 850,180. (Courtesy Ray Medeiros.)

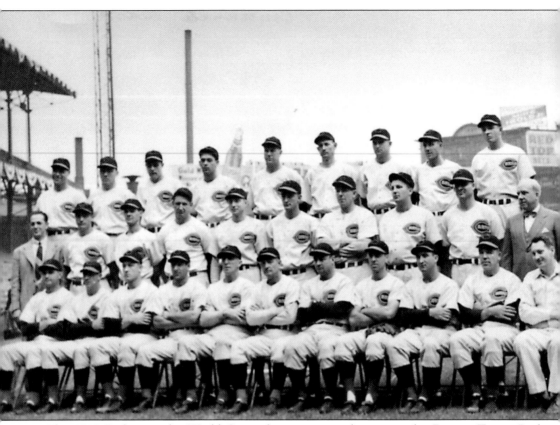

The 1940 Reds won the World Series four games to three over the Detroit Tigers. Paul Derringer and Bucky Walters each won two games. Pictured from left to right are: (front row) Lew Riggs, Ival Goodman, Gene Thompson, Morris Arnovich, coach Hank Gowdy, manager Bill McKechnie, coach Jimmy Wilson, Bill Werber, Billy Myers, Elmer Riddle, and Dr. Richard Rhode, trainer; (second row) Gabe Paul (road secretary), Lloyd Moore, Eddie Joost, Ernie Lombardi, Bucky Walters, Frank McCormick, Paul Derringer, John Hutchings, Bill Baker, and Warren Giles (general manager); and (third row) Jim Turner, Jimmy Ripple, Johnny Vander Meer, Mike McCormick, Milt Shoffner, Witt Guise, Harry Craft, Lonnie Frey, and Joe Beggs. (Courtesy Ken Smith.)

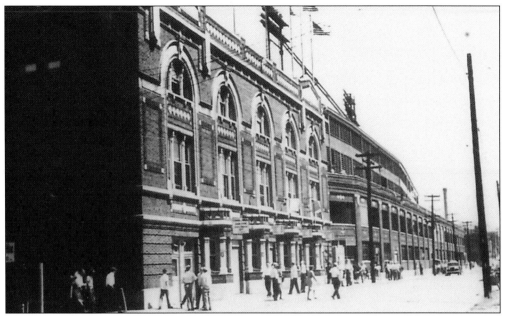

The Reds slid to third in 1941 (88-66) and drew 634,513 fans to Crosley Field.

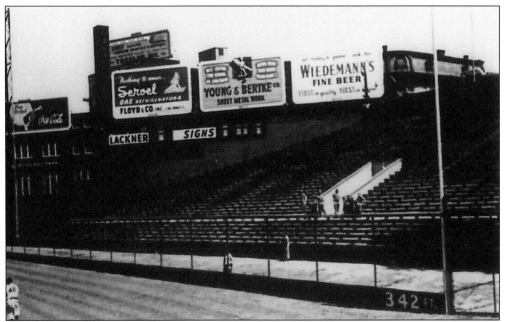

In 1942 the Reds installed a wall in front of the right field bleachers, shortening the foul line from 366 feet to 342. The club dropped a notch in the standings to fourth place (76–76) and attracted 427,031 fans. (Courtesy Ray Medeiros).

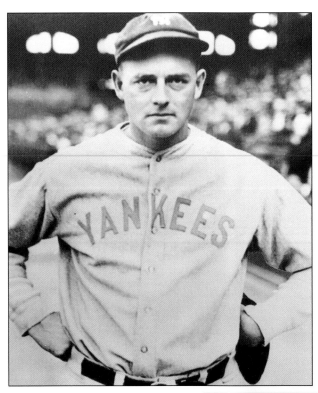

Former Hall of Fame pitcher Waite Hoyt, who wrapped up a 21-year career with Brooklyn in 1938, began a 24-year broadcasting career with the Reds in 1942.

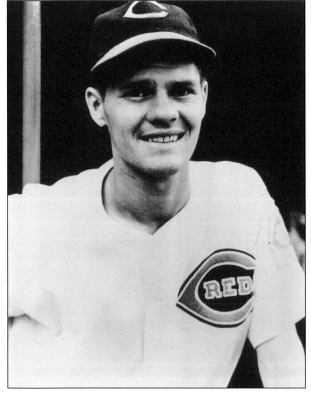

Infielder Eddie Joost broke into the majors with the Reds in 1936 and was part of the pennant winners in 1939–1940. His last season with the Reds was 1942. Joost would go on to play for the Boston Braves and would be the regular shortstop for the Philadelphia Athletics from 1947 to 1952. Relegated to a backup role for the next few seasons, Joost managed the Athletics in 1954 while inserting himself into 19 games, batting .362 and playing the field in 15 games. He was let go as manager after a last-place finish and finished his career as a player with the Red Sox in 1955, with a lifetime .239 average. (Courtesy B&W Photos.)

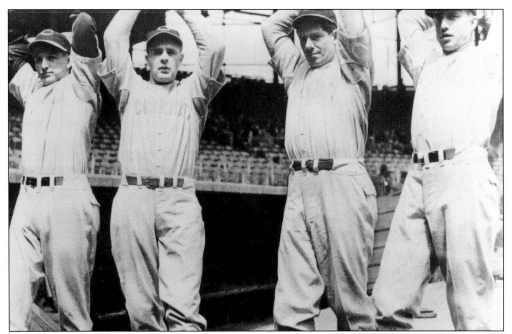

1942 marked the last time Reds pitchers (from left) Paul Derringer, Johnny Vander Meer, Whitey Moore, and Bucky Walters were teammates. Only Vander Meer and Walters remained in 1943 as the Reds tried to trade their way into contention. (Courtesy B&W Photos.)

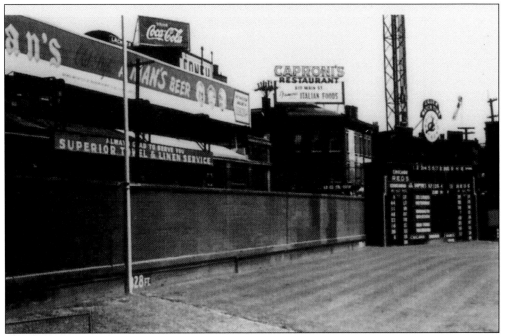

The field was reconfigured in 1943 as home plate became 66 feet from the backstop. The left field wall was 328 feet away, and the left side of the 37-foot high scoreboard was 382 feet from the plate. Lefthanded batters were unhappy as the right field foul line measured 383 feet. (Courtesy Ray Medeiros.)

Outfielder Frank Kelleher was up for parts of the 1942 and 1943 seasons with the Reds. His big league career consisted of 47 games and a .167 batting average. Kelleher went on to work in the tool distribution business in California.

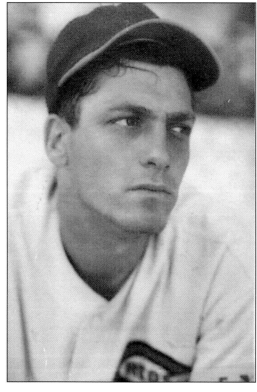

From 1938 to 1943, in between trips to the minors, Dick West was a poor-hitting backup catcher who managed a .221 career average. West went on to serve in the Navy in World War II and worked in the lumber, box, and packaging business. (EHC-BHC-DPL.)

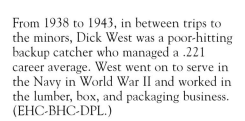

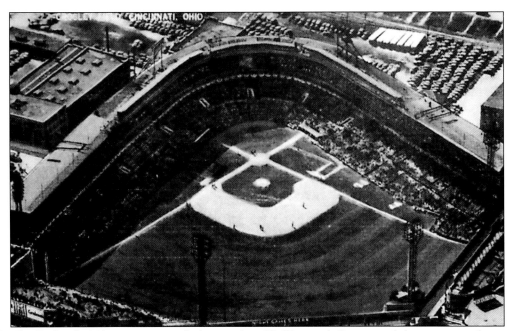

The Reds of 1943 rose to second place with a 87-67 record. Because of the war, attendance dropped to 379,122. (Courtesy Ray Medeiros.)

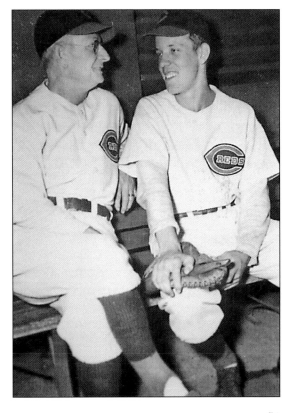

Manager Bill McKechnie (left), welcomes the youngest player to ever wear a big league uniform. Joe Nuxhall, only 15, made his major league debut on Saturday, June 10, 1944, as many pitchers in the Reds system were off to war. Nuxhall was shelled by the Cardinals as he gave up five walks, a wild pitch, two hits, and five earned runs. Nuxhall wouldn't get back to the Crosley Field mound again until 1952. (Courtesy Cincinnati Reds.)

Hank Gowdy, a big-league catcher for 17 years, was wearing a major league uniform in the same years that he went off to serve in World Wars I and II. Gowdy coached for the Reds from 1938 to 1942, and again when he returned from service in 1945 and 1946.

Frank McCormick, the regular first baseman since 1938 with a batting average over .300, was sold to the Boston Braves in June 1945. The popular McCormick would return to Crosley Field as a telecaster from 1958 to 1968. (EHC-BHC-DPL.)

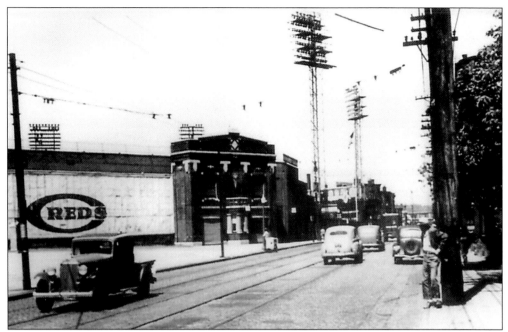

After a third-place finish in 1944, the Reds dropped to seventh in 1945 and attendance skidded to 290,970. (Courtesy Ray Medeiros.)

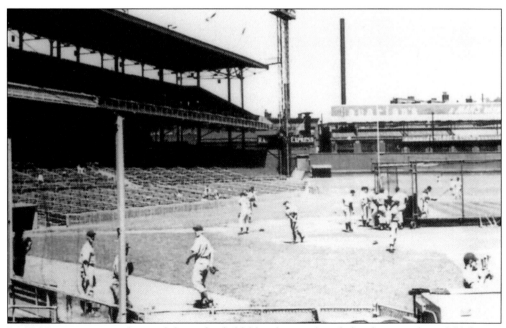

In 1946, new seats in front of the right field bleachers reduced the distance from 366 feet to 342 feet, but the club fell to sixth. Attendance rose to 715,751 and the managerial era of Bill McKechnie ended. (Courtesy Ray Medeiros.)

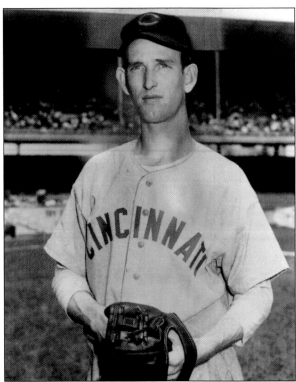

1947 belonged to Ewell "The Whip" Blackwell. Blackwell pitched a no-hitter and rattled off 16 consecutive victories while winning 22 games as the Reds improved to fifth and attendance rose to 899,975.

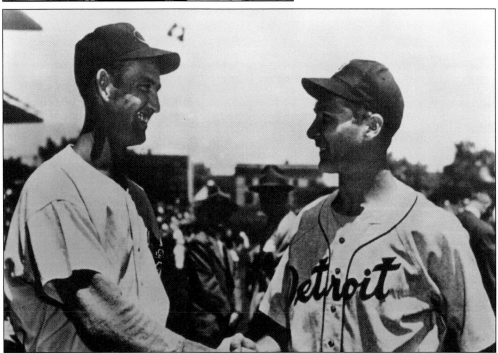

Blackwell (left) and Hal Newhouser were the starting pitchers at the 1947 All-Star Game at Wrigley Field. Each pitched three innings and surrendered one hit while not allowing any runs. However, Blackwell bested Newhouser four strikeouts to none. (Courtesy B&W Photos.)

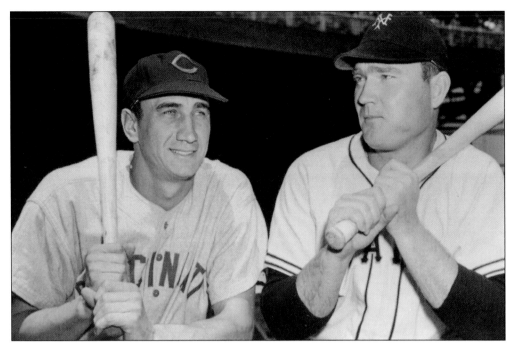

Outfielder Hank Sauer (left) hit 50 home runs for Triple-A Syracuse in 1947, while Johnny Mize hit 51 for the New York Giants. In 1948, in his only full season with the Reds, Sauer hit 35 homers while Mize hit 40. (Courtesy B&W Photos.)

Ken Raffensberger, who pitched two one-hitters against the Cardinals in 1948, posted an 18-17 record with a 3.39 ERA in 1949, while pitching 284 innings and giving up a league-leading 289 hits. (Courtesy Ken Smith.)

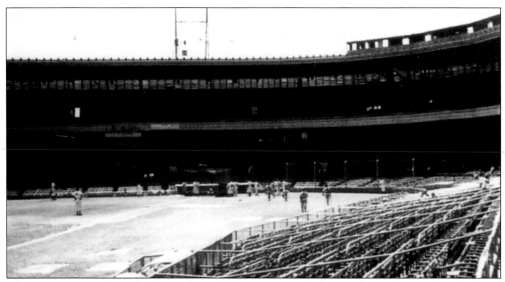

This interior view of Crosley shows the infield as it appeared when Bucky Walters replaced Johnny Neun as Reds manager, with the club in seventh place, in 1948. Walters finished the season in that position and was let go late the following season with the club in seventh place again. The Reds of the 1940s had a 767-769 record, a .499 winning percentage. (Courtesy Ray Medeiros.)

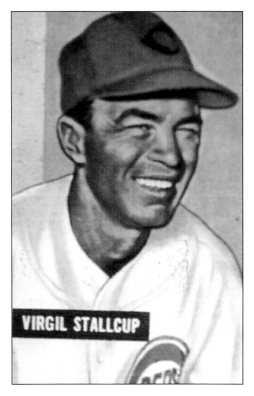

Shortstop Virgil Stallcup had his best season batting average of a seven-year career in 1949 when he hit .254 in 141 games. (Author's collection.)

FOUR

The 1950s

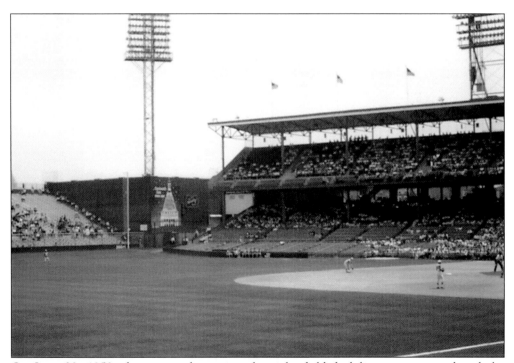

On June 30, 1950, the screen shortening the right field foul line was removed and the distance to the right field wall was back to 366 feet. The 1950 season would be the first of four consecutive sixth-place finishes. (Photo by Author.)

Hobie Landrith broke in with the Reds in 1950. He would be a backup catcher for the Reds through 1955 and move on to six more clubs in a 14-year career.

Traveling secretary Gabe Paul was elevated to general manager of the Reds after Warren Giles vacated the position and was named National League president in 1951. (EHC-BHC-DPL.)

Outfielder Danny Litwhiler, who was traded to the Reds in 1948, remained through 1951, when he ended an 11-year career. Litwhiler would go on to a long career as head baseball coach at Michigan State University and would develop several baseball aids, including the radar gun.

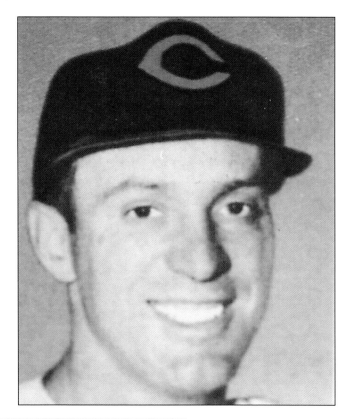

Promoted from coach to manager late in the 1949 season, Luke Sewell was let go 98 games into the 1952 season with the club mired in seventh place. (Author's collection.)

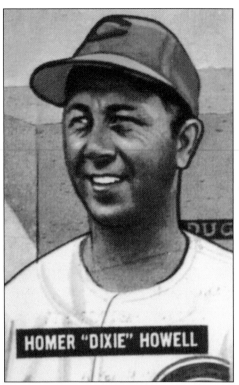

Backup catcher Dixie Howell was with the Reds from 1949 to 1952. Dixie was from Louisville, Kentucky, and his real first name was Homer. Howell had 12 homers in his eight-year career in 910 trips to the plate and had a .246 lifetime average. (Author's Collection.)

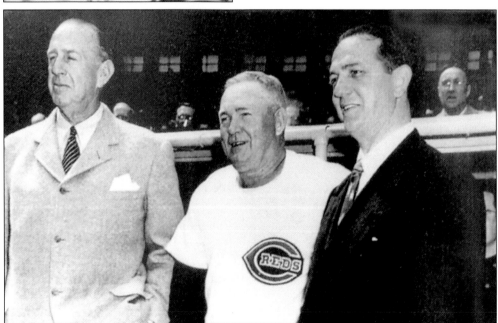

With the St. Louis Browns in seventh place in 1952, manager Rogers Hornsby was fired, and was hired by the Reds. Hornsby's Reds were 27-24, ending the season in sixth place. Hornsby, flanked by Reds owner Powell Crosley (left.) and Gabe Paul on opening day in 1953, would be fired 148 games into the season, with only 69 wins and the team in sixth place. (Courtesy Ken Smith, National Baseball Library and Archive, Cooperstown, NY.)

Outfielder Willard Marshall hit three consecutive home runs for the New York Giants and also played for the Boston Braves before coming to the Reds in the 1952 season. In 1953—his only full season with Cincinnati—Marshall hit 17 home runs while batting .266. (EHC-BHC-DPL.)

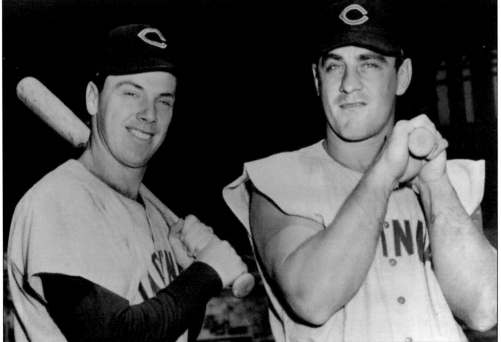

After three seasons with the Pirates, outfielder Gus Bell (left) hit 30 homers for the Reds in 1953 while batting .300 and driving in 105 runs. First baseman Ted Kluszewski bettered Bell's marks by hitting 40 home runs, batting .316 with 108 RBIs.

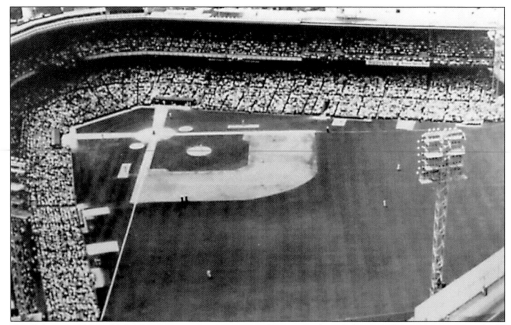

On July 14, 1953, 30,846 paying customers saw the second and final All-Star game ever held at Crosley Field. Gus Bell and Ted Kluszewski represented the Reds as the American League defeated the Nationals 5-1. During the season, the backstop was 78 feet from the plate and the right field screen was back up, creating a 342-foot foul line. (Courtesy Ray Medeiros.)

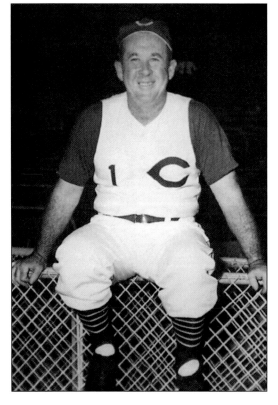

1954 was the first of four full years under new manager Birdie Tebbets—a former major league catcher for 14 seasons. (Courtesy Cincinnati Reds.)

Art Fowler's first year of a nine-year big league career started with the Reds in 1954. Fowler was 12-10 with a 3.83 ERA. Fowler would go on to a long career as a pitching coach. (Courtesy Cincinnati Reds.)

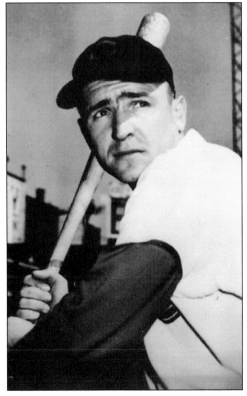

Outfielder Jim Greengrass played in all 154 games for the Reds in 1953 and hit 20 homers. His last full season with the Reds was in 1954, when he hit 27 home runs. (Courtesy B&W Photos.)

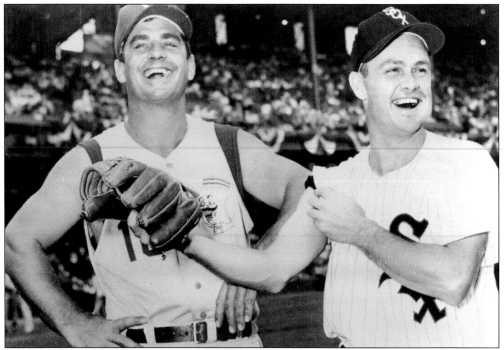

White Sox All-Star second baseman Nellie Fox would hit 35 home runs in a 19-year career. Ted Kluszewski (left) hit 49 home runs in 1954. Fox would have six .300-plus seasons, while Klu would better him with seven .300-plus seasons in 15 years. The pair would be teammates on the pennant-winning 1959 White Sox. (Courtesy B&W Photos.)

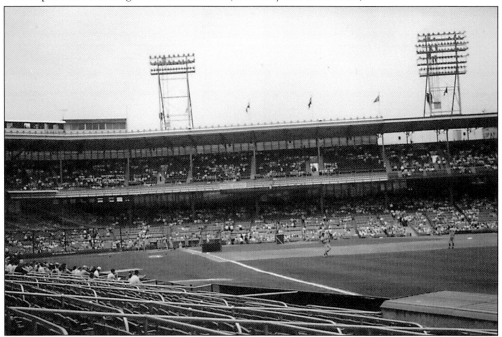

After three seasons in which attendance topped 600,000 only once, the 1954 Reds drew 704,167 as the club finished fifth for the first time since 1947. (Photo by Author.)

In 1955 attendance dipped to 693,662 as the Birdie Tebbets-led Reds finished fifth again. However, a bright spot was the pitching of Joe Nuxhall, who compiled a 17-12 record with an ERA of 3.47. (Courtesy B&W Photos.)

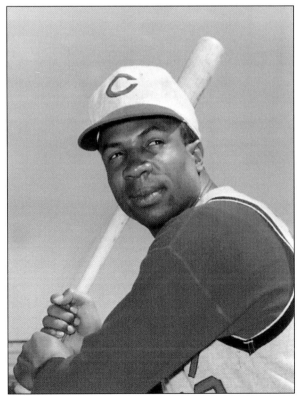

National League Rookie of the Year Frank Robinson brought extra punch to the Reds lineup in 1956. Robinson hit a rookie record 38 home runs and batted .290. (Courtesy B&W Photos.)

Catcher Ed Bailey, who came up to the Reds in 1953, was a regular by 1956 and responded with a .300 average and 28 home runs.

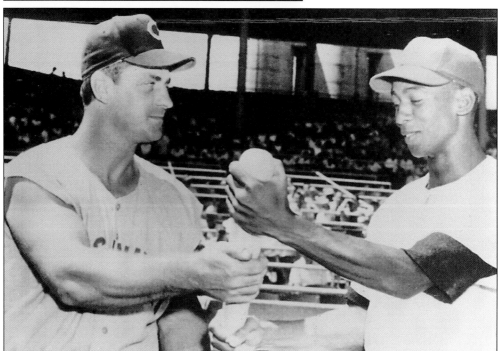

After three 40-plus homer seasons, Ted Kluszewski (left) hit 35 home runs and batted .302 in 1956. After two 40-plus homer seasons, Cubs shortstop Ernie Banks slugged 52 home runs while batting .297. (Courtesy B&W Photos.)

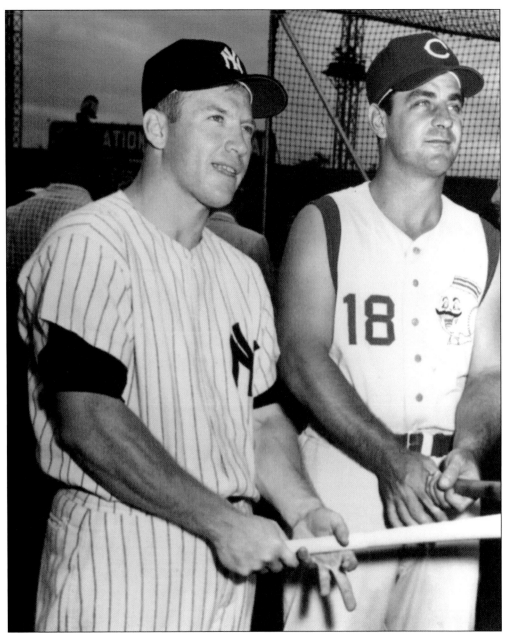

Mickey Mantle (left) and Ted Kluszewski check bats at the 1956 All-Star Game at Griffith Stadium in Washington. Mantle won the American League Triple Crown as he batted .353 with 52 home runs and 130 RBIs. (Courtesy B&W Photos.)

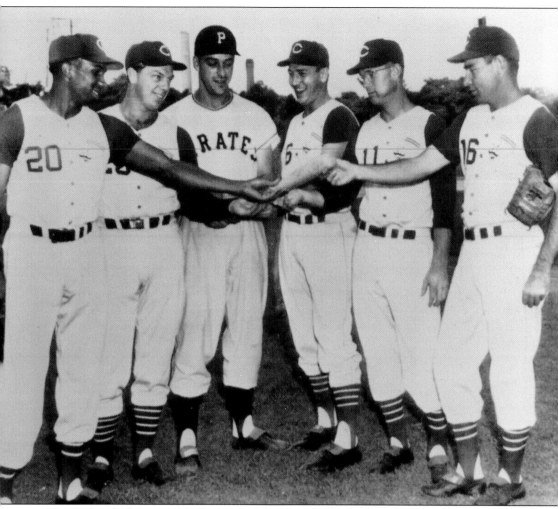

The Reds talk batting with Pirates first baseman Dale Long prior to a game at Pittsburgh's Forbes Field. Pictured from left to right are outfielders Frank Robinson and Gus Bell, Long, catcher Ed Bailey, shortstop Roy McMillan, and second baseman Johnny Temple. Long hit a home run in each of eight consecutive games in May 1956. (Courtesy B&W Photos.)

Catcher Ed Bailey welcomes veteran pitcher Larry Jansen to the Reds. Jansen won 96 games in his first five seasons with the New York Giants. Jansen was rescued from the minors by the Reds in 1956; he then won two games and lost three. (Courtesy B&W Photos.)

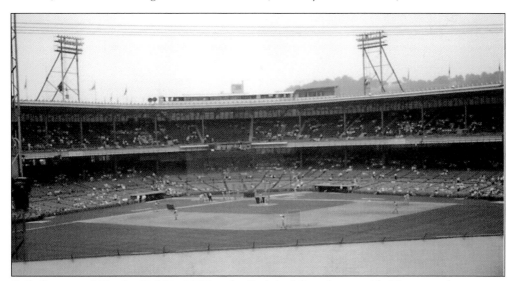

Balls flew out of Crosley Field in 1956 as the Reds had five players with 20 or more home runs. The club finished third, winning 91 games, and attendance topped the million mark for the first time ever as 1,125,928 fans paid their way into the tiny ballpark. (Photo by Author.)

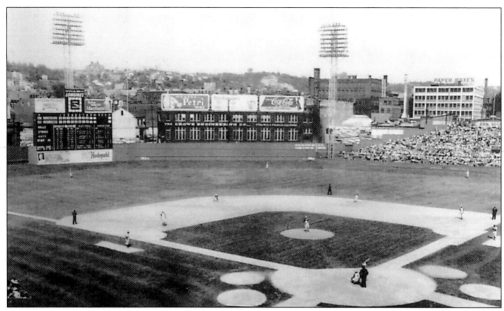

A new scoreboard—65 feet wide and 50 feet 2 inches high—was installed for the 1957 season. The 7-foot 10-inch clock made the new board 58 feet high The Reds had another winning season as the team won 80 games and finished fourth. Attendance was less than the previous season but still topped the million mark—1,070,850. (National Baseball Library, Cooperstown, NY.)

Traded to the Reds in 1952 by the Brooklyn Dodgers, Bud Podbielan managed to stay with the Reds until 1957 and compiled a 19-34 record. (EHC-BHC-DPL.)

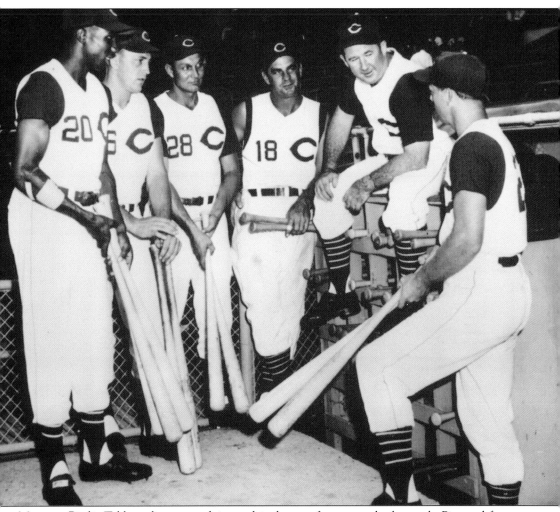

Manager Birdie Tebbets dispenses advice to his sluggers from atop the bat rack. Pictured from left to right are Frank Robinson, Ed Bailey, Wally Post, Ted Kluszewski, and Gus Bell. Post and Kluszewski were traded after the 1957 season. (Courtesy B&W Photos.)

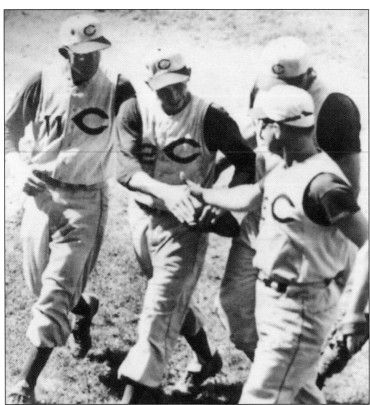

Pitcher Harvey Haddix, obtained by the Reds from the Phillies for Wally Post, is congratulated by his new teammates. Pictured from left to right are Roy McMillan, Haddix, Steve Bilko, and Eddie Miksis. 1958 was the only year Haddix spent with the Reds, and he had an 8-7 record with a 3.52 ERA. (AP Photo courtesy EHC-BHC-DPL.)

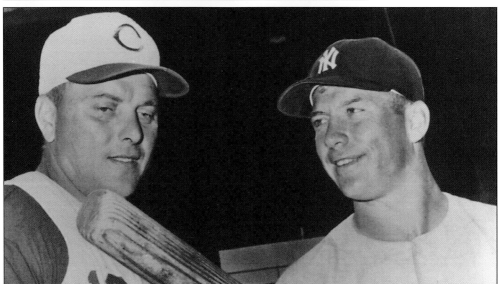

Steve Bilko (left) only spent 31 games with the Reds in the 1958 season. Bilko had starred for the Los Angeles Angels of the Pacific Coast League two years earlier by hitting 55 home runs, batting .360, and driving in 164 runs. The Reds packaged Bilko and Johnny Klippstein to acquire Don Newcombe from the Dodgers. Bilko never hit more than 21 homers in a major league season. His 10-year career average was .249. Mickey Mantle had another great year in 1958 as he batted .304 and hit 42 home runs. (Courtesy B&W Photos.)

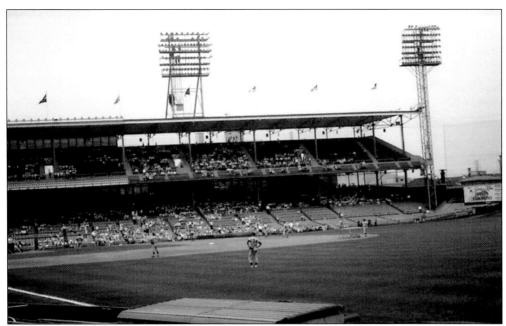

With the Reds in seventh place after 113 games into the 1958 season, Birdie Tebbets was fired. Coach Jimmie Dykes took over and managed the club to a 24-17 finish as the Reds ended up in fourth place and drew 788,582 fans. (Photo by Author.)

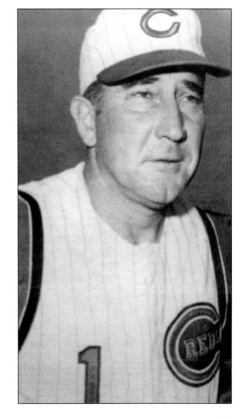

Mayo Smith began the 1959 season as Reds' manager but was terminated after 80 games with the club in seventh place. Former big league pitcher Fred Hutchinson managed the Reds to a 39-35 finish as the team rose to a fifth place tie. For the decade, the Reds had a 741-798 record, a .481 winning percentage. (EHC-BHC-DPL.)

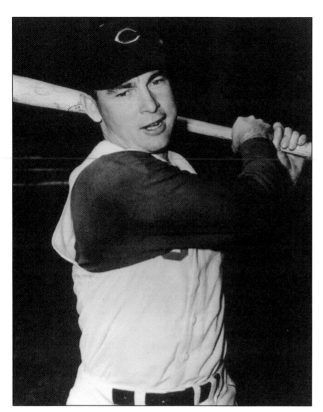

Johnny Temple came up to the Reds in 1952 and was the regular second baseman by 1954. He hit .281, .285, .284, .306, and .311 from 1954 through 1959 before being traded to Cleveland. (Courtesy B&W Photos.)

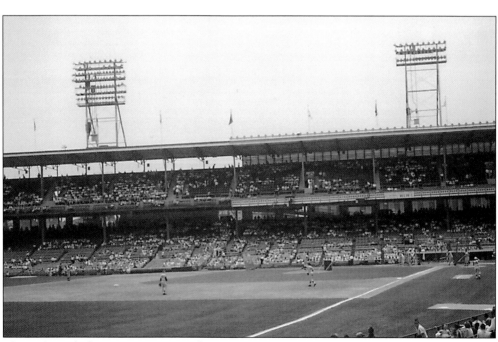

The 1959 Reds drew 801,298 paying fans into cozy Crosley Field. (Photo by Author.)

FIVE

The 1960s

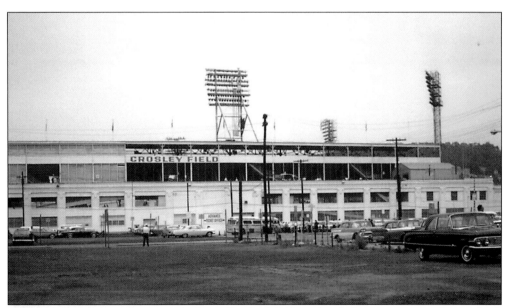

The new decade brought a new look to Crosley Field as the dark exterior was whitewashed. (Photo by Author.)

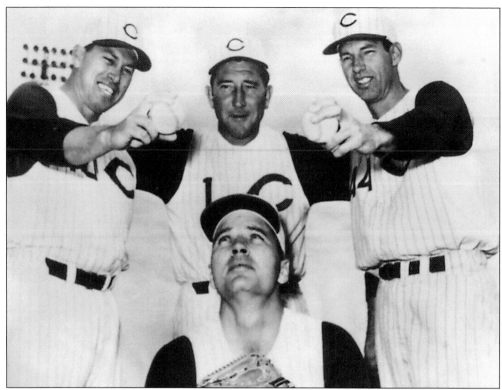

Manager Fred Hutchinson poses between new acquisitions for the 1960 season. Pictured from left to right are Pitcher Cal McLish, Hutchinson, and pitcher Bill Henry, all looming above catcher Frank House.

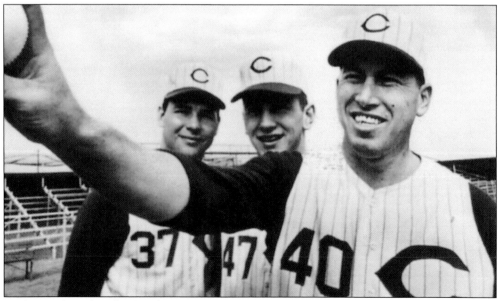

Pitchers Bob Purkey (left) and Jay Hook stand behind their new mate Cal McLish. 1960 would be McLish's only season with the Reds in his 15-year career; he would have a record of 4 wins and 14 losses. (AP Photos courtesy EHC-BHC-DPL.)

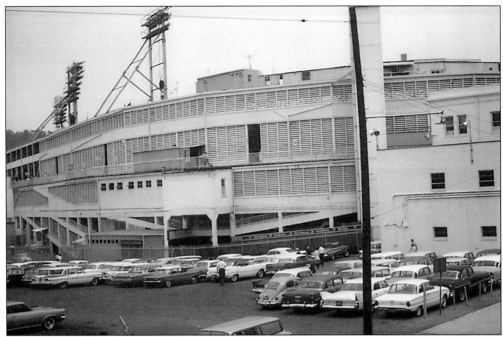

The 1960 Reds under Fred Hutchinson finished sixth (67-87) and drew 663,486 fans. (Photo by Author.)

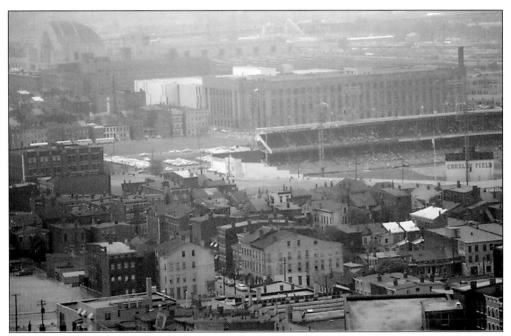

Buildings around Crosley Field were demolished for parking and to make room for I-75. (Photo by Author.)

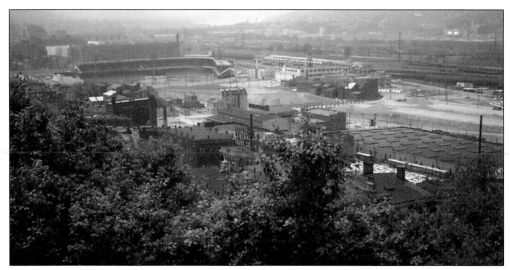

Going into the 1961 season, the Reds boasted that there were 6,000 parking spaces in municipal and private lots.

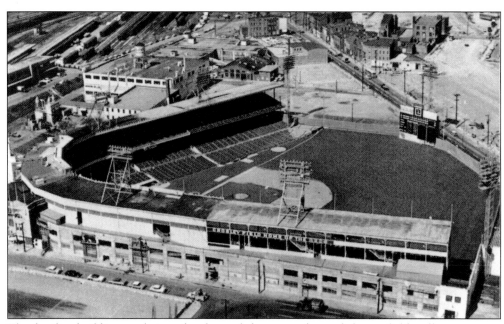

The familiar buildings and signs that hugged the streets beyond the outfield walls were gone. (Courtesy Ray Medeiros.)

Pitcher—later turned author—Jim Brosnan had his best season in 1961 as he won 10, lost four, and saved 16 out of the bullpen, with an ERA of 3.04. (Courtesy B&W Photos.)

Reds fans were hoping for many wins out of (from left) Jim Maloney, Claude Osteen, Jim O'Toole, and Jay Hook. Maloney won six but Osteen didn't win any before being traded. O'Toole, however, won 19. Hook had only one win.

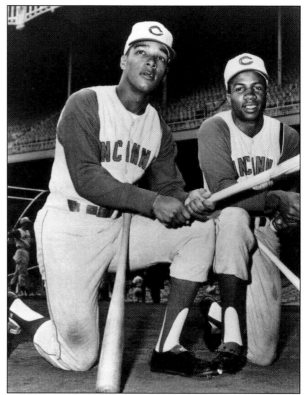

Vada Pinson (left) and Frank Robinson swung big bats for the Reds in 1961. Pinson hit .343 with 16 home runs, while Robinson averaged .323 with 37 homers. (Courtesy B & W Photos.)

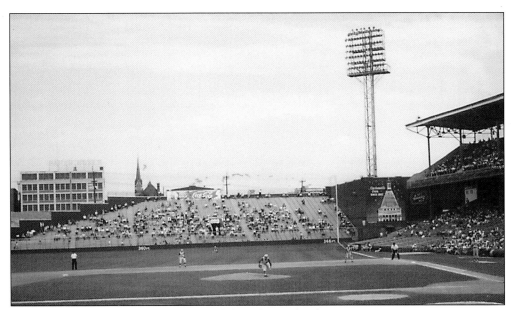

The Reds of 1961 drew 1,117,603 fans. (Photo by Author.)

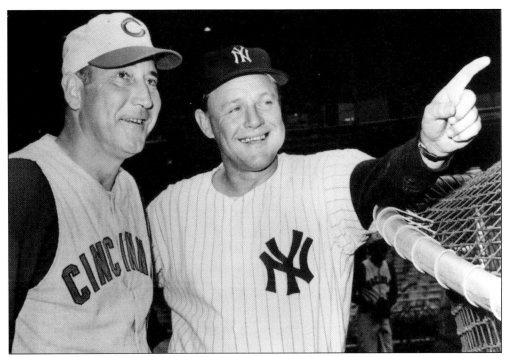

Fred Hutchinson (left) and Ralph Houk meet at Yankee Stadium prior to Game One of the World Series. The Reds won 93 regular season games, while the Yanks won 109. (Courtesy B&W Photos.)

The only Reds' World Series victory in 1961 came in Game Two at Yankee Stadium. The heroes, pictured from left to right are catcher John Edwards, first baseman Gordy Coleman, pitcher Joey Jay, and second baseman Elio Chacon. Jay went all nine innings and pitched a four-hitter, while Coleman homered and Edwards and Chacon contributed key hits in the Reds' 6-2 victory. (AP Photo courtesy EHC-BHC-DPL.)

The Series moved to Cincinnati all tied up. Starting pitchers for game three were Bill Stafford (left) and Bob Purkey. Stafford pitched 6.2 innings and allowed two runs, while Purkey went the distance, losing the game 3-2. (Courtesy B&W Photos.)

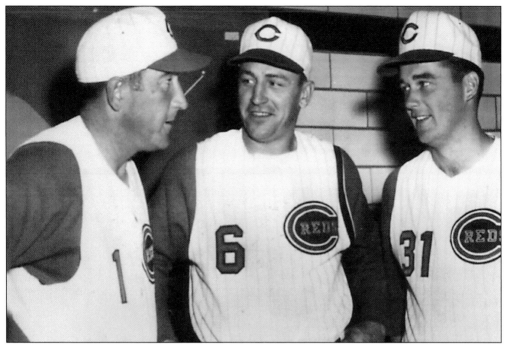

Manager Fred Hutchinson chats with catcher Ed Bailey and pitcher Jim O'Toole. O'Toole would pitch two games in the World Series and lose both. O'Toole pitched 12 innings, surrendered 11 hits, and posted a 3.00 ERA.

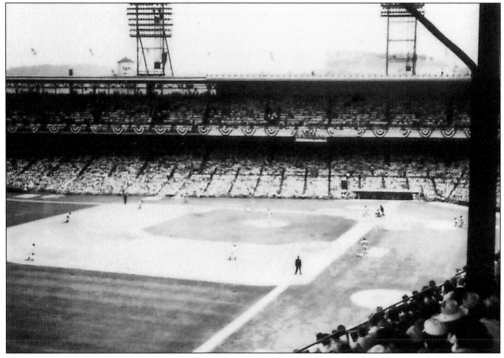

Games three, four, and five in Cincinnati drew the same paid attendance of 32,589. The Yankees clinched the Series by winning Game Five, 13-5. (Courtesy Ray Medeiros.)

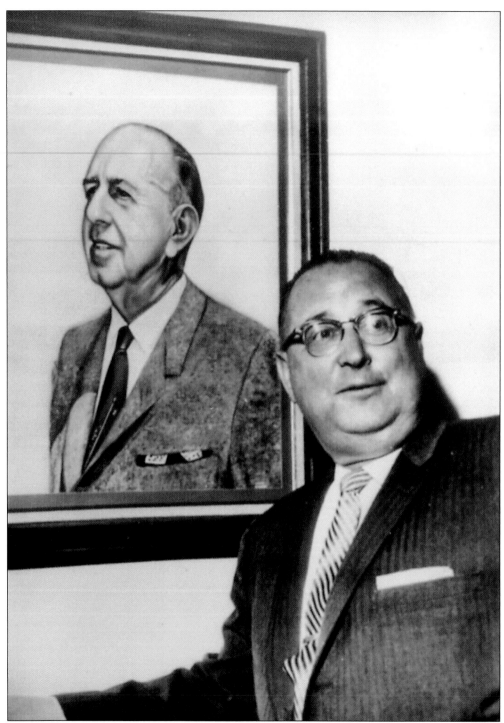

Bill DeWitt, who became general manager after the departure of Gabe Paul, bought the Reds from the Crosley Foundation. Fittingly, DeWitt posed beneath a painting of the late Powell Crosley Jr. (EHC-BHC-DPL.)

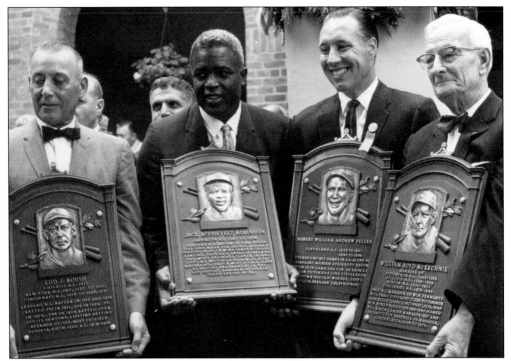

Two former Reds of yesteryear were inducted into the Hall of Fame in 1962, along with Jackie Robinson and Bob Feller. Pictured from left to right are Edd Roush, Robinson, Feller, and Bill McKechnie. (AP Photo courtesy Chicago Promotions.)

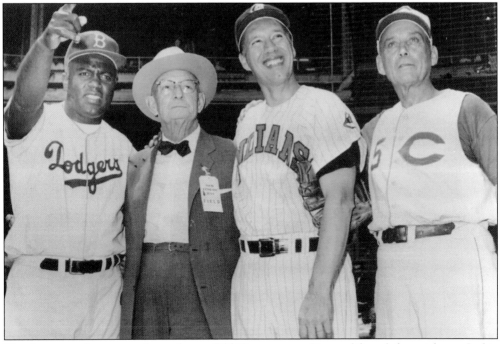

The foursome also appeared together at Old-Timer games. Pictured from left to right are Jackie Robinson, Bill McKechnie, Bob Feller, and Edd Roush. (Courtesy B&W Photos.)

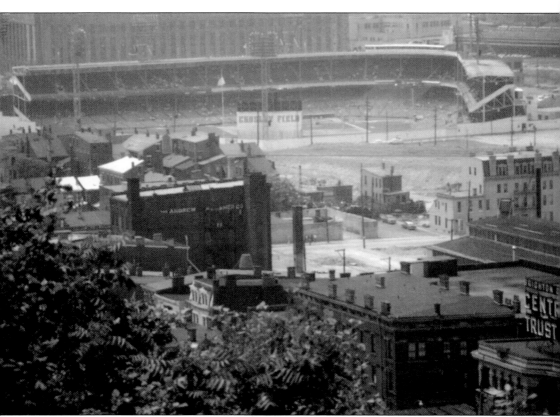

Despite Bob Purkey's 23 victories and Frank Robinson's outstanding season (.342 batting average, 39 home runs, and 136 RBIs), the 1962 Reds slipped to third place. The club won 98 games as 982,095 fans paid their way into Crosley Field. (Photo by Author.)

Pete Rose made his major league debut in 1963. Rose was the first home-towner to play for the Reds since Herm Wehmeier in 1954. (Courtesy B&W Photos.)

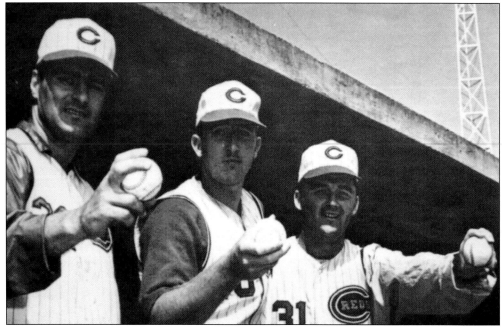

Joey Jay (left), who won 21 games in 1961 and 1962, had an off year in 1963 as he posted a 7-18 record. Jim Maloney won 23 games in 1963 and Jim O'Toole had 17 victories. (Courtesy Cincinnati Reds.)

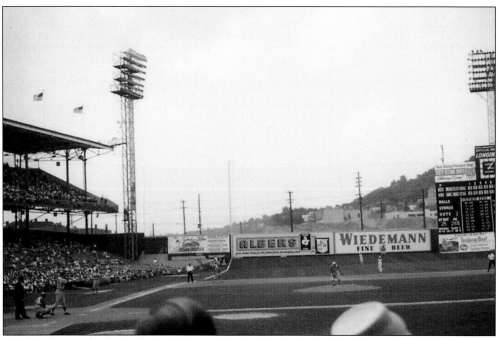

Frank Robinson had an off year in 1963 as he batted .259 with 21 home runs and 91 RBIs in 140 games. The Reds won 86 games, finished fifth, and drew 858,805 to colorful Crosley Field. (Photo by Author.)

Cancer forced Fred Hutchinson to resign as manager 109 games into the 1964 season with the Reds at 60 victories and 49 losses. Former major leaguer Dick Sisler, who played with the Reds in 1952, became manager and guided the club to a 32-21 finish. The 92 combined wins were good enough for second place. Hutchinson died at the age of 45 in November 1964. (Courtesy B&W Photos.)

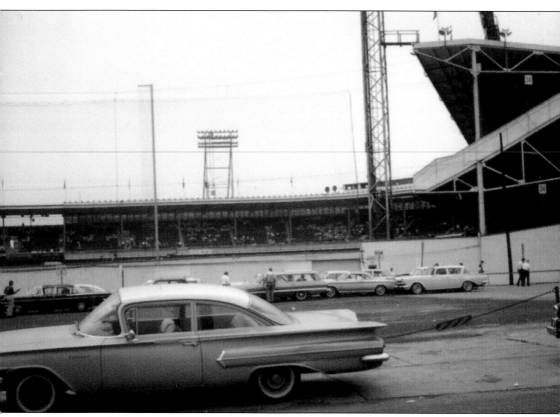

The fence above the left field wall protected parked cars from being dented by baseballs. More cars parked around Crosley Field in 1965 as the Reds drew 1,047,824. It was the first time the Reds went over the million mark since 1961. However, fans would miss the home runs hit by Frank Robinson as the Reds traded the slugger—who hit 30 or more home runs seven different seasons—to Baltimore after the season. (Photo by Author.)

Jim Maloney, who won 23 games two years earlier, won 20 games in 1965 and pitched a no-hitter against the Mets. Despite Sammy Ellis' 22 victories, the Reds finished fourth in 1965. (Courtesy Cincinnati Reds.)

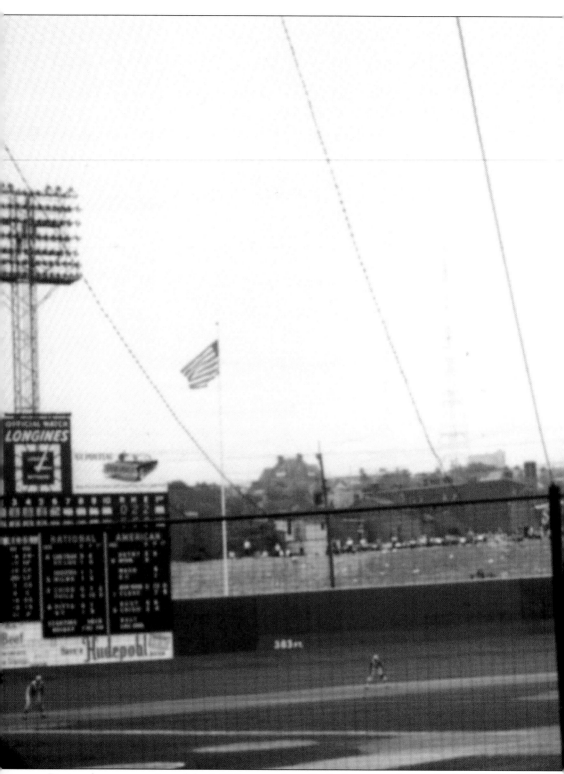

During the construction of the I-75 freeway, fans climbed on top of mounds of dirt beyond the

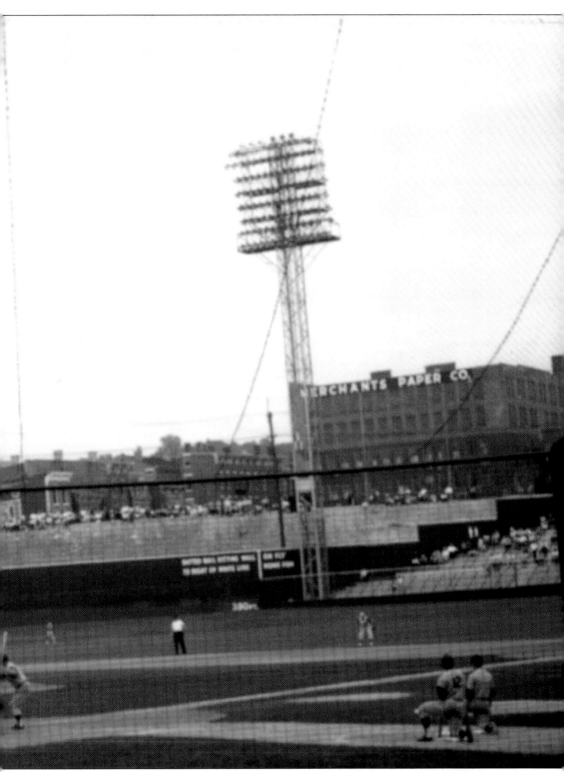

outfield wall and watched the games without paying any admission. (Photo by Author.)

Cincinnati had a drab, unattractive waterfront in the 1960s before its stadiums were constructed.

Buildings on each side of the bridge would be removed in a few years for a stadium and parking. (Photos by Author.)

114

Art Shamsky homered in four consecutive at-bats and totaled 21 home runs in 96 games during 1966. Shamsky would go on to play for the Mets and starred during their 1969 pennant-winning season by hitting .300 and .538 in the National League Champion Series. (Courtesy B&W Photos.)

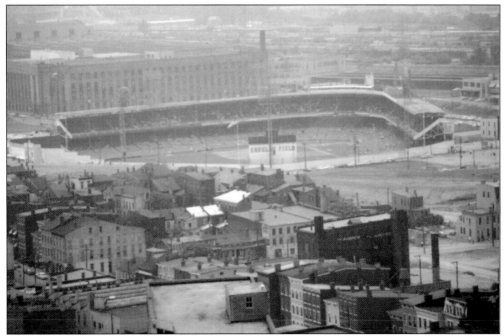

In 1966 Bill DeWitt sold the Reds to Francis Dale, publisher of the *Cincinnati Enquirer*. The Reds slipped to seventh place and attendance dipped below 743,000. (Photo by Author.)

Johnny Bench began his Hall of Fame career with the Reds in 1967 by batting .163 in 86 at-bats. (Courtesy B&W Photos.)

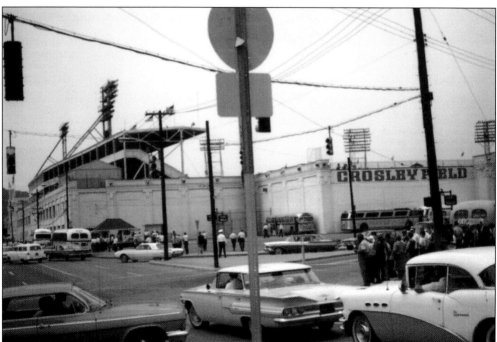

The longest game ever at Crosley Field took place on September 1, 1967. The Giants beat the Reds 1-0 in 21 innings. (Photo by Author.)

The 1967 Reds finished fourth and drew over 958,000 fans.

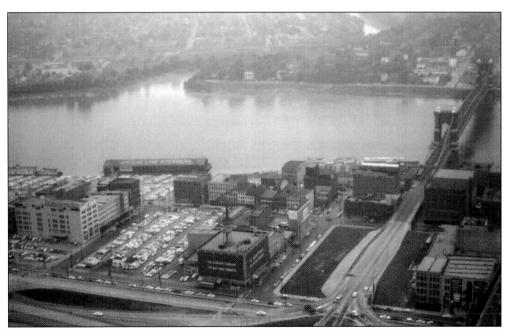

In 1967 construction began on the site of what would become Riverfront Stadium. (Photos by Author.)

In 1968 Johnny Bench (left) became the regular catcher for the Reds and was named Rookie of the Year. Tony Perez was the regular third baseman, and the pair helped the Reds to a 83-79 record and a fourth-place finish. While construction progressed on a new stadium on the waterfront, only 733,354 fans paid their way into Crosley Field. (Courtesy B&W Photos.)

Gerry Arrigo, who pitched a one-hitter for Minnesota five years earlier, pitched a one-hitter for the Reds in 1969. Arrigo won 35 and lost 40 over a 10-year big league career.

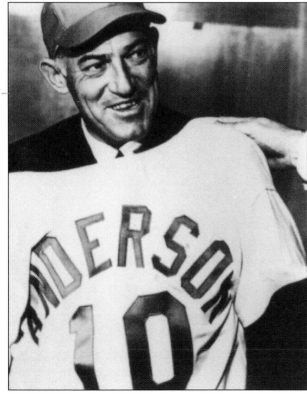

George "Sparky" Anderson was hired as Reds manager after the departure of Dave Bristol in October 1969. (AP Photos courtesy EHC-BHC-DPL.)

In 1969, as the second deck of Riverfront Stadium was taking shape and the lower bowl was being enclosed, Crosley Field was the site of Jim Maloney's third career no-hitter for the Reds.

The following day—April 31—Don Wilson of the Astros pitched a no-hitter against the Reds.
(Photo by Author.)

1969 was the last full season the Reds played in Crosley Field. The club drew 987,991 and

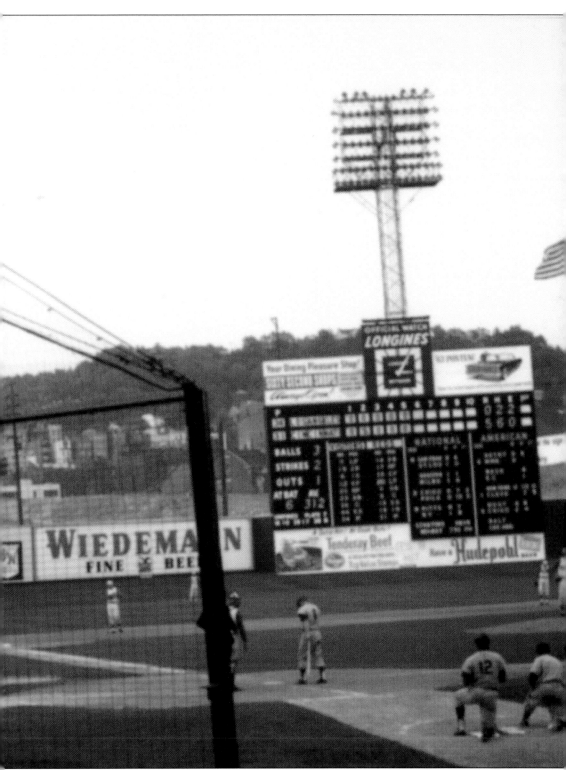

finished third. Fifty of the Reds' 89 victories came at Crosley Field. (Photo by Author.)

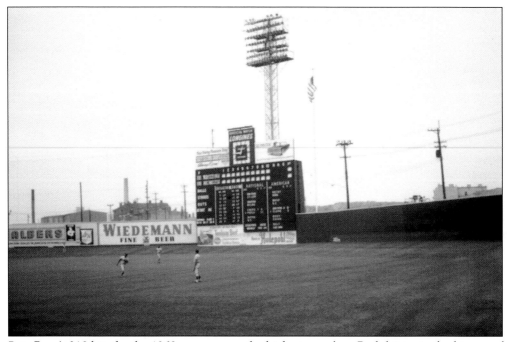

Pete Rose's 218 hits for the 1969 season were the highest ever by a Reds hitter in the history of Crosley Field. (Photo by Author.)

In 1970 Cincinnati native Pete Rose signed a contract for $105,000, making him the first Reds player to earn six figures. (Courtesy B&W Photos.)

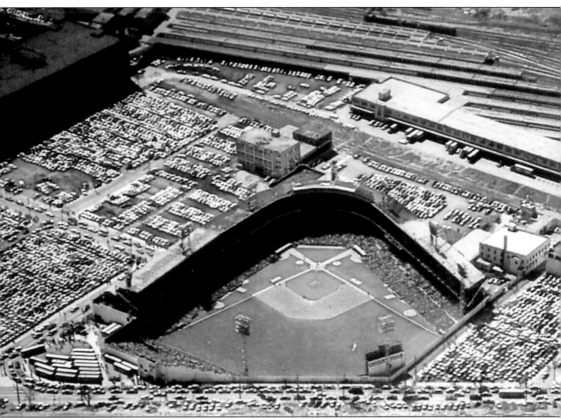

The last game played at Crosley Field—the 4,453rd game played there—was on June 24, 1970. Many of the 28,027 paying fans came early in the evening to soak up memories and watch the last sunset as the night game progressed. Lee May and Johnny Bench hit back-to-back home runs in the eighth inning to beat the Giants' Juan Marichal 5-4. In 34 dates that year at Crosley Field, the Reds drew 567,937. (Courtesy Ray Medeiros.)

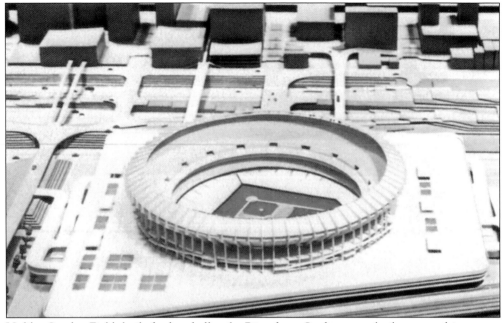

Unlike Crosley Field, built for baseball only, Riverfront Stadium was built as a multi-purpose stadium. (Courtesy Ray Medeiros.)

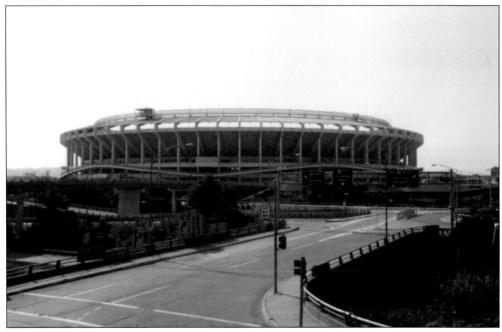

At a distance from the outside, first-time visitors to the circular stadium couldn't tell which side the infield, outfield, right field, or left field were on. (Photo by Author.)

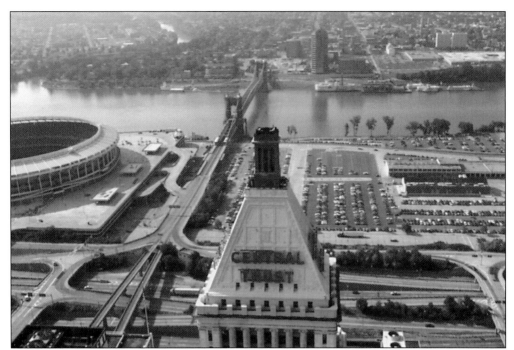

The first game played at Riverfront Stadium was on June 30, 1970. The Reds lost 8-2 to Atlanta before 51,050 paying fans. (Photo by Author.)

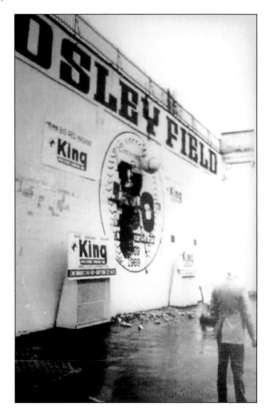

On April 19, 1972, the demolition of Crosley Field began when a wrecking ball hit a bullseye logo on the exterior of the right field wall. (Courtesy Ray Medeiros.)

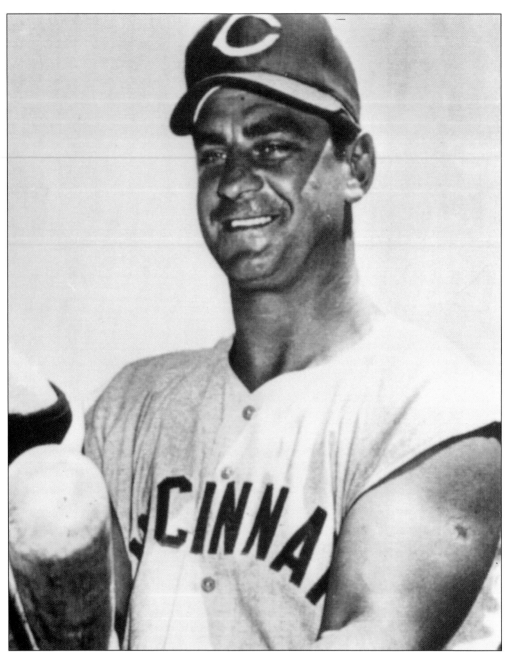

While Crosley Field was the tiniest ballpark in the major leagues, the Reds boasted the most muscular man in the majors. From 1947 to 1957, Ted Kluszewski was one of the most popular players on the Reds. Big Klu hit 251 homers for the Reds, and the left-handed batting slugger also led the league in fielding for five straight years (1951-55). In 1954 Big Klu batted .326 and led the league in home runs (49) and RBIs (141) while striking out only 35 times. Kluszewski had more homers than strikeouts for five consecutive seasons. It was fitting that Kluszewski began his coaching career with the Reds in 1970—the year Crosley Field saw its last game. Old timers still wonder how many more home runs Big Klu would have hit if Crosley Field didn't have the farthest distance down the right field line of any big league ballpark. (Courtesy B&W Photos.)